Contemporary Art: Exploring Its Roots and Development

Contemporary Art
Exploring Its Roots and Development

Charlotte Buel Johnson
Curator of Education, Albright-Knox Gallery, Buffalo, New York

DAVIS PUBLICATIONS, INC., Worcester, Massachusetts

PREFACE

This book, *Contemporary Art: Exploring Its Roots and Development*, will assist teachers of junior and senior high school levels in introducing their students to the painting and sculpture that has been developed since World War II in the United States. Artists have continued in bold experimentation with new materials resulting in new directions and unprecedented growth.

Students at the secondary level do not have much direct experience with art either in the classroom or in an art museum. However, in Buffalo, New York, such students have shown themselves to be especially responsive to art of their own time, contemporary art, during visits to the Albright-Knox Art Gallery. They are attracted not only to the subject matter presented by the contemporary artist but also by the unusual materials and the unusual techniques which are consequential. Unlike many of their elders, these students are not put off or offended by a painting of a soup can, by a junk metal sculpture, or by a composition made up solely of geometrical forms. Their curiosity is aroused by these art objects which they recognize as belonging to their own environment and era. By contrast, they are apt to be less responsive to art of earlier times except when considering it in relation to another area of study, and their interest then is perhaps more academic than anything else.

There is no need to make this book an extensive one, covering all periods, because numerous competent surveys of art are already available. Instead, a restricted set of examples has been chosen, the earlier ones providing background for the later ones of post-World-War-II. These examples also serve to demonstrate that each period produces art expression peculiar to that period, which is a kind of continuity in itself. They also serve to demonstrate another sort of continuity, that of ideas and methods. Certain concepts of the contemporary artist have roots in the past.

The book has two parts. Part One is an introduction to contemporary art using examples reaching back only to the Middle Ages, on through the Renaissance, the nineteenth century, and the early years of the twentieth century. Admittedly there are potential examples from much earlier times and from cultures other than those selected; these omissions are intentional.

Part Two is devoted to key developments in American art since World War II. These are Abstract Expressionism, new sculpture, the re-examination of the environment by the Pop artists, the new elements of motion and

light, the optical expressions, and a group of artists who represent the possibility of still newer directions.

Realism has not been included because that subject merits examination by itself. This type of expression goes back to the very earliest times and continues on in the twentieth century. It should be remembered that a well-known realist artist like Andrew Wyeth is a contemporary of the artists discussed in this text who are active and significant since 1945. His paintings, and the work of others of his persuasion, are very much a part of the scope of American art since World War II.

The illustrations for the text are selected as suitable examples which represent as many collections as possible. Collections of twentieth century art are comparatively few in number and the finest and most extensive of these are concentrated in a limited area in the eastern part of the United States.

Since the book is an introduction for teachers, some of whom might not be familiar with art, there is an appendix containing a selected bibliography and a list of museums and galleries with sufficiently significant collections of twentieth century, and especially contemporary, art, as well as a list of sources for reproductions, slides, and films on art.

The book is meant to prompt discoveries on the part of the reader. To this end the Foreword is planned to encourage both the knowledgeable reader and the novice. Through this text book and supplementary material and activities, students will have their enjoyment and understanding broadened and deepened.

The author is indebted to many persons too numerous to list. Gordon M. Smith, Director of the Albright-Knox Art Gallery, generously granted permission to use the many examples from the Gallery's collection which form the nucleus of the study. It is extremely doubtful that the book would have been possible without this very fine representation of American art after 1945 as a working tool. The office of the Registrar was extremely helpful in the gathering of photographs and the ascertaining of data. The author is indebted to the staffs of the many other art institutions, represented in this book, who graciously granted permission for photographs and provided data. Perhaps even more important are the many students and teachers with whom the author has been associated during more than twenty years of museum experience. This association has been invaluable in the development of this book.

6

FOREWORD

The artists presented in the text are not the only representatives of the various developments of the twentieth century. The three types of projects suggested below should expand and deepen the student's experience even more. Pertinent to this, the selected bibliography, the list of museums and galleries with twentieth-century art collections, and the list of sources for reproductions and slides appear in the Appendix (pages 93-96).

Individual research

1. A rather extensive study of an artist of particular interest can be made, including the finding of biographical information. The student can determine how this relates to the artist's work and to that of other artists who are his contemporaries.

2. Comparative study of two or more artists of divergent styles and interests, but active at the same time, provides insight into the cultural aspects of a given period.

3. Much can be gained from examining in depth a group of artists who have a common interest, such as the light artists, Pop artists, sculptors who weld, and so forth. For every artist cited in the text, there are others whose work will make rewarding study.

4. What about the controversial conceptual artists? Their interests are varied and their relation to the visual arts is quite apart from tradition.

5. The course of realism in the twentieth century makes an interesting study. While other styles have come to the fore from time to time, realism has never died out. Besides Andrew Wyeth, who are other realists of this century? To what subjects have they turned their attention? How have they expressed this?

6. What exhibitions of importance have occurred during the past seventy years? For example, the Armory Show of 1913 has many angles to be studied. Why was it organized? Who were the artists included? What were the reactions to it? What influence did it have on the art world?

Steiglitz' gallery, "291," had many significant exhibitions. What were they? Why have they been important?

7. What role does the art museum play in twentieth-century life and especially today, in the 1970s? It collects and preserves art and presents special exhibitions, but what else does it do? How does it add to the life of its community?

8. Are things happening in music, in poetry, or in other areas of literature, that compare with the situation in the visual arts?

7

9. Prehistoric art, Egyptian art, and African art have abstract qualities. Look for examples that demonstrate relationships to twentieth-century art.

The practice of art

1. It is one thing to look at art and to read about it. It is another to tackle the actual problem of making a painting, a collage, a sculpture, or a drawing. One's understanding of art is greatly enhanced by actually producing a work of art. Whether the result is "great" or not is beside the point. The involvement with materials and techniques to express ideas is a big step toward deepening understanding and appreciation. One can explore on one's own, or form a club with friends, or join a class. An art class can serve the nonmajor art student very well and enhance other areas of study while providing opportunity for individual development.

2. Local artists have much to offer. Make visits to their studios. Ask them to give demonstrations and discussions of their work.

The organization of exhibitions

1. The work of local artists is interesting to gather and mount as an exhibition.

2. The local museum or gallery sometimes can provide a loan exhibition.

3. The gathering of art and the researching of background material about the works and their artists for a catalog is both interesting and useful.

4. Lacking the original work of art, excellent exhibitions can be formed from reproductions and from photographs of sculpture and architecture. There are reproductions of small sculpture of various periods which provide good material, too.

5. The forming of a library of color reproductions for display and study is a good project for any school. When these are securely mounted, they also become a circulating library for enjoyment at home, like library books.

Living with art is the best way to get to know and understand it.

6. The found object has been important in the development of twentieth-century art. To form collections of shells, driftwood, stones, scrap material, and anything with interesting shape, texture, and color is a fascinating and long-range project. While these found objects make intriguing exhibitions, they are also the raw material for creating a variety of compositions.

7. Making up notebooks or folios about some facet of art that particularly appeals is another aspect of this project of collecting. Newspaper articles, illustrations from magazines, and postcards can all be found. The nearby museum or gallery is an excellent starting point, not only for the study of its collection, but for what it stocks in its sales department.

In connection with all three of these kinds of projects, films about art should not be overlooked (see Appendix). There are the long feature films presenting the artist and his life. There are many short films showing the artist at work which frequently offer considerable commentary either by the artist speaking about his work or by a narrator. There are films which present a particular period or movement in art. There are films which are works of art in themselves and were made to communicate an idea in their terms just as a painting or a sculpture does.

The paths to follow lead in many directions. The foregoing projects have been made brief in order to stimulate the finding of additional projects. An ultimate goal would be to have art assume a normal part of daily life rather than to have it set apart as a thing to be looked at only in a museum at a special time or to be read about in a book or an article. Painting, drawing, sculpture, all the visual arts, along with the making of things, are normal human activities and modes of expression and enjoyable too.

CONTENTS

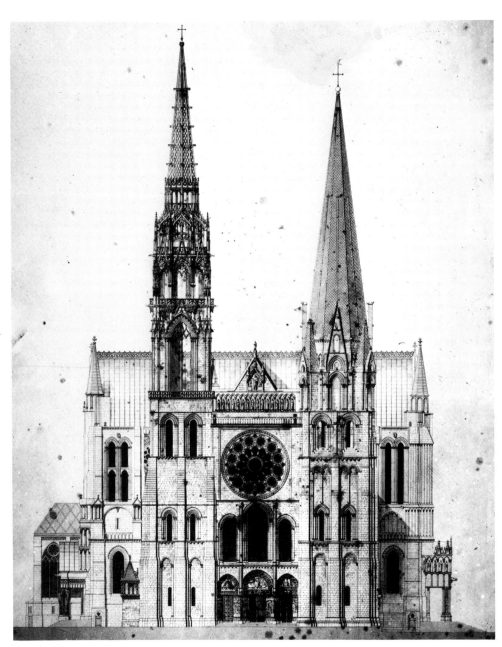

1. West facade, Cathedral of Notre Dame, Chartres.

The artist's environment figures importantly in what he expresses. His environment provides the materials he uses and these dictate his methods or techniques. It also produces the attitudes and needs of the people he meets. His fellow artists influence him in style and method and are a source of inspiration. Likewise the artist's predecessors, not only immediate ones but earlier ones as well, exert influence. Yet, in the final analysis, the artist makes his own statement, solving the artistic problem according to his own vision and his own reactions to current needs.

During the Middle Ages, Christianity was a dominant force. Constantine officially recognized it in

Part One

ROOTS OF CONTEMPORARY ART

400 A.D., and Christian groups began to assemble openly. This required suitable meeting places, and churches for Christian worship soon rose to meet the needs for ceremony and expression of beliefs. The first of these churches were existing buildings which the Christians adapted to their own uses. New ones evolved, especially planned to express Christianity—its worship and doctrine. The Gothic cathedral, especially in France, epitomizes this expression, and one of the finest examples appears in the *Cathedral of Notre Dame*, largely of the twelfth century, at Chartres (Figure 1). The townspeople of Chartres quarried and brought stone from Berchères-l'Evêque, five miles away, and built the structure itself.[1] The fervor with which these people worked under master masons, stonecarvers, and glaziers stemmed from their unquestioning belief in the Virgin Mary to whom they dedicated the building. The soaring pillars and delicately pointed spires demonstrate their aspiration to heaven and salvation. Their beliefs are pictured in the carvings surrounding the portals and in the jewel-like stained glass windows illuminating the interior.

The west portal, complete by 1150 A.D., of Chartres includes reliefs depicting the labors of the months together with the signs of the zodiac, illustrating the belief of the faithful that through labor man could gain salvation. The sculptor of these monthly labors has left us charming vignettes of everyday life in twelfth-century Chartres, using tools and methods handed down from

1. Adams, Henry: *Mont-St. Michel and Chartres.* Garden City: Doubleday, p. 111.

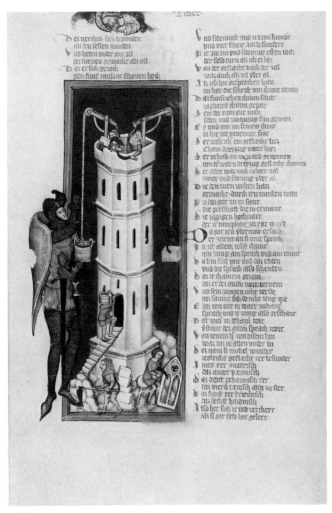

(Above)
2. German, Fourteenth Century
Christ-Herre Chronik (Morgan Ms. 769, f28ᵛ)
13½" x 9½"
The Pierpont Morgan Library, New York, N.Y.

(Right, top)
3. Antoniazzo Romano (Italian, d. 1512)
The Annunciation, ca. 1480
39¾" x 45"
Isabella Stewart Gardner Museum, Boston, Mass.

(Right, bottom)
4. Giovanni del Biondo (Italian, 1356–1392)
The Annunciation: the Virgin, ca. 1366
Tempera on wood, cradled, 23" x 14½"
Albright-Knox Art Gallery, Buffalo, N.Y.
Elizabeth H. Gates Fund.

master to apprentice. The means of expressing the subject was patterned after manuscript illustrations and borrowed from contact with Byzantine art since little sculptural expression then existed to guide the artist. The picturing of the labors of the months reflected the four mirrors of Vincent of Beauvais who, in the spirit of the growth of universities and the renewed search for knowledge, classified all knowledge in terms of four categories, or mirrors.[2] Among these his mirror of science (instruction) included human labor.

A leaf from a fourteenth-century German manuscript, *Christ-Herre Chronik*, shows a tower being built (Figure 2). One laborer is bowed over by a heavily laden basket which he carries into the building. Two more are on top of the tower and one of them is laying stones. Alongside the laborers are two rope hoists, one on either side of the tower. One carries up a bucket and the other brings up a block of stone. In the foreground a craftsman works on the stone frame for a stained glass window while another appears to be cutting stone blocks. Here, in a Church manuscript, human labor is once again dignified by its association with a religious task. In addition, using the style and the painting materials of the fourteenth century the artist has provided fascinating documentation of architectural construction of the period. The tower being built is the Biblical Tower of Babel. God the Father appears at the top of the page in accordance with Genesis 11:5 which contains the account of the building of the Tower of Babel. The oversized figure at the left is identified as Nimrod, the legendary giant who built this tower and who included Babel in his kingdom (Genesis 10: 8–10). It is no wonder that Nimrod appears taller than anyone else.[3]

One of the major developments in pictorial art came when the system of perspective was developed in Italy. First practiced by Filippo Brunelleschi (1377-1446), Leon Battista Alberti (1404–1472) then revised and developed it further. Mathematically based, perspective consisted of organizing the illusion of three-dimensional depth on a flat surface by means of parallel lines converging to a vanishing point. Objects can then be scaled to size according to their depth along these lines. The resultant illusion of reality gives the viewer the sensation of actually witnessing the scene or an event rather than a flat representation of it. This method reflected philosophical

2. Male, Emile: *Medieval Art*. New York: Pantheon, pp. 62–77.
3. Letter to author, June 5, 1972. The Pierpont Morgan Library, William Voelkle, Acting Curator of MSS.

12

and social changes. The man of the Middle Ages concerned himself largely with the next world. The man of the Renaissance became concerned with the world he lived in, so he studied it, finding much of interest, and even attempted to master it. Religious fervor lessened, and earthly life and material matters dominated thought and activity.

The Annunciation by Antoniazzo Romano, *ca.* 1480, demonstrates this perspective system very well (Figure 3.) Everything seems to recede, and straight lines appear to converge to a vanishing point. The very surface of the panel seems to have been painted away and considerable space opened up to accommodate the setting and the principal actors of the story. The figures of both the Angel Gabriel and Mary, shown as ideal humans, typify the Renaissance period. The architecture itself, no longer Medieval, reflects that seen in any fifteenth-century Italian city. The building style is particularly reminiscent of both Brunelleschi's and Alberti's work.

A brief look at Giovanni del Biondo's tempera panel of the Virgin, *ca.* 1366, (Figure 4) indicates the essential differences between these two periods. This earlier Virgin is stylized and thoroughly two-dimensional against a decorative background of gold leaf and the representation of red and gold brocade cloth meant to hang behind the throne. Neither the gold nor the hanging describe space. What might pass for modelling to show a third dimension really only distinguishes one part from another on a flat plane.

The statue of St. Gorgon (Figure 5), carved from pear wood between the years 1480–1510, probably in France, portrays a young noble of that period. The painted surfaces enhance the idea of the rich materials of his garments. The artist has depicted the Saint, who really lived centuries before, as one of his own contemporaries. Thus the Saint must have seemed closer and more real to his later followers in Northern Europe. The symbols refer to the young noble's Christian life. He carries a prayer book in one hand and a falcon on the other. The falcon, a creature for sport, also symbolized conversion for the Christian. Originally a wild creature, the falcon could be tamed to hunt for his master and thereby lead a new life. The Christian entered into a new life through baptism and through his adoption of the Christian way with Christ as his Master. The falcon came to symbolize this change in status.[4]

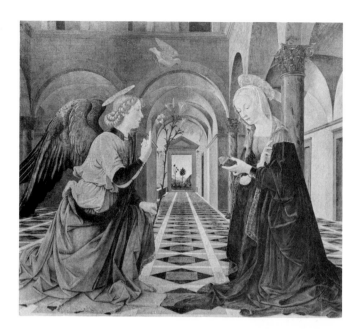

13

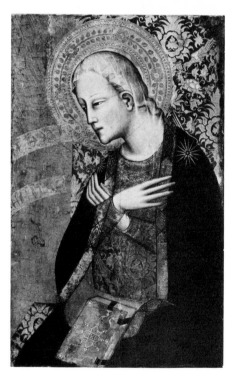

4. Ferguson, George: *Signs and Symbols in Christian Art.* New York: Oxford University Press, n.d., p. 15.

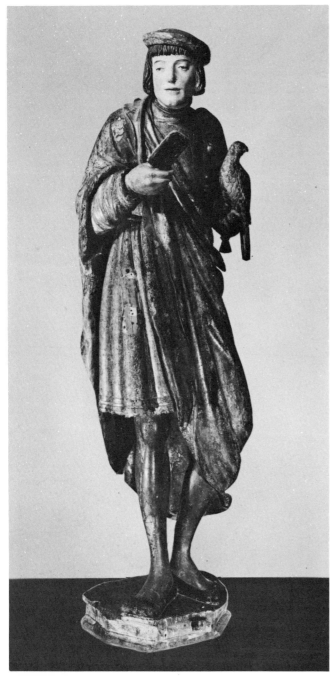

14

5. French, *ca.* 1480–1510
St. Gorgon
Polychrome tempera on fruit wood, 66" high
Albright-Knox Art Gallery, Buffalo, N.Y.
Charles Clifton Fund.

Remains of an old inscription give evidence that this is St. Gorgon, a young noble in the court of Diocletian who converted to Christianity. The artist has expressed the subject in terms of his own time—wood carving was popular in Northern Europe—using tempera paint over the gesso surfacing to describe the clothing. The humanistic interpretation of the subject, making St. Gorgon into a believable person and a contemporary of the artist, was a practice of the period, the result of Renaissance influence.

The *Très Riches Heures*, painted *ca.* 1516 by Pol de Limbourg and his brothers for the Duc de Berri in Flanders, reflects the feudal life of Northern Europe. Essentially a prayer book, this manuscript, which is executed in tempera paint and gold leaf on vellum, contains pages which give us an intimate view of daily life much like the earlier Cathedral carvings. The message is the same: work and prayer together are a means to salvation. The prayers for the month are illustrated by typical activities on the fief. Pol de Limbourg had observed and experienced daily life there and painted it. In each, one of the Duc's chateaux dominates the background. The painter used the materials readily available: vellum, or animal skin, especially prepared, and natural pigments, earth colors for the most part, mixed with egg whites. Gold leaf was used for accent. Picture, materials, and method all reflected the time.

The system of perspective to show shape and depth or space on a flat surface was known and used in Italy in the fifteenth century, but was not adopted in Northern Europe until the sixteenth century. The shapes and space of the *Très Riches Heures* still depended on the artist's ability to paint approximately how things appeared to be but without benefit of the mathematically based system, perspective. Consequently proportions seem perhaps illogical and parts of the picture are placed "up" to appear distant. The lack of a perspective system, however, does not detract from the fine and delightful aesthetic quality.

The sixteenth-century Flemish *Book of Hours of the Virgin* (Figure 6) provides an apt comparison to the *Très Riches Heures*. One page of this book shows a boating party in the foreground. The two ladies and the two gentlemen have gathered branches. One lady plays a lute and one man a flute. Behind on the far shore the artist placed riders on horseback and a castle surrounded by trees and a moat. This charming view of a May day is important for itself as well as for its religious

message which seems almost secondary. This scene illustrates one of the Four Mirrors which were Vincent of Beauvais' way of classifying all knowledge. In the manuscripts, as well as in the cathedral carvings, typical activities of the months were depicted, giving insight into the life of the time. This sheer enjoyment of nature was intensified by the realization that the world was a reflection of the creation of God and therefore the slightest leaf or flower or branch was of importance.[5]

Until the latter part of the nineteenth century, painting and sculpture in Europe and in America developed in a tradition that carefully prescribed method and allowed little, if any, opportunity for invention or individuality. Subject matter was mainly limited to historical, religious, or literary ideas. However, the American Revolution and the French Revolution engendered a spirit of freedom and revolt which could not be ignored. The younger artists in France increasingly defied tradition. The Impressionists, a group whose work charted new courses for art, emerged from them.

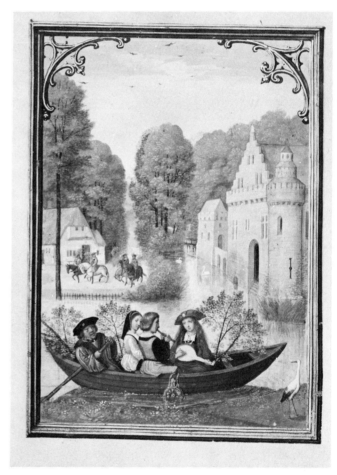

6. Flemish, Sixteenth Century
Book of Hours of the Virgin (Morgan Ms. #399 f6')
6¾" x 4⅞"
The Pierpont Morgan Library, New York, N.Y.

5. Male, Emile: *Medieval Art*, New York: Pantheon, pp. 62–77.

From 1874 until 1886, Claude Monet and his followers dominated the art scene, and it is their work which came to be known as "Impressionism." They were revolutionary because they painted untamed nature (landscapes), working on the spot and out-of-doors. They were also revolutionary because they explored the potential of color and exploited their findings. They found color, form, and space relationships to be affected by light and atmosphere. They expressed this by painting what they saw under given conditions much as a camera records what is in front of it. Taking advantage of new colors and pigments developed by modern chemistry, they evolved a technique of divided color to better express what they observed. They realized that the eye combined juxtaposed colors into new colors, and they devised the daubed-on technique to show this. For example, instead of mixing green on their palette, they applied daubs of yellow and blue side by side on the canvas to appear green to the viewer. The resulting painting lacked usual defined space and shape and appeared to be two-dimensional.

Critics and gallery-goers alike were confounded. This new attitude recurred later in the twentieth century, and some artists turned their attention to optical aspects of color, making this their subject. Increasingly, painting became two-dimensional. Monet's *Woman Seated under the Willows* (see first page, top, color section) demonstrates the technical qualities of Impressionism and the color effects that resulted. The light sparkles and the viewer senses, above all, sunlight and shadow rather than definition of three-dimensional form and space. It is an objective view of a fleeting moment.

If Impressionism was a radical development, Cubism was even more so. Actually Cubism continued the countermovement begun by Post-Impressionism, a reaction to the vagueness of Impressionism. The Post-Impressionists strove to re-establish the importance of solidity, volume, and defined space. In its turn, Cubism approached these matters in yet another innovative way.

The work of Paul Cézanne formed an important stepping stone to Cubism. Cézanne used color to build solid three-dimensional natural shapes which he kept close to their basic geometric form by leaving out details. Cézanne also began to unite the surfaces of these objects with their surrounding spaces. For example, in the painting, *The Artist's Son, Paul* (see first page, bottom, color section), Cézanne has built a solid-looking figure. However, the brush work used to apply the yellow ochre color of the background creates a foil for the complementary blue of the boy rather than providing a reference to surrounding space. The artist is concerned more with abstract problems than representational ones. In addition, the brush work for the blue areas closely resembles that used for the ochre ones, and this tends to unify the areas and therefore to lessen three-dimensionality considerably.

Pablo Picasso, the Spaniard who settled in Paris early in the 1900s must have known the work of Cézanne at least through exhibitions. In 1907, he painted the first truly twentieth-century picture, *The Maids of Avignon (Les Demoiselles d' Avignon)* (Figure 7) which forecasts innovations to come in pictorial expression while at the same time deriving much from the past. The picture refers to many traditions: heroic women of earlier times, early Spanish sculpture, simple shapes united with their background in the manner of Cézanne, and the then contemporary interest in African Negro carving. The painting respects the nineteenth-century interest in the past while also recognizing contemporary developments. The predictions of things to come lie in the flattened and rearranged figures, the emphasis on physical force and energy, and the fact that the colors exist independent of representation. The figures seem to be united with the surrounding spaces, and the composition appears to move out in all directions without a focal point.

Picasso went on to develop what came to be known as Cubism, for which the main period of activity was between 1909 and 1914. However, Picasso and his immediate circle continued to open more new paths for exploration and extension by others in more recent times.

One of Pablo Picasso's colleagues, Juan Gris, has described Cubism as " . . . simply a new way of representing the world . . . a reaction against the fugitive elements of the Impressionist painters, feeling the need to discover the stable elements in the objects to be represented." He also said that " . . . in the beginning Cubism was a sort of analysis." [6]

The analytical *Portrait of Daniel Henry Kahnweiler* (Figure 8) painted by Picasso in 1910 provides many views of one object. These views have been assembled into a new view which is not a faithful representation of the actual person. Picasso has used virtually one color to fuse forms and the surrounding space into a new unity. This method calls for comparison with Cézanne's

6. Source for these quotations: Gray, Christopher: *Cubist Aesthetic Theories.* New York: Arno Press (reprint), p. 45.

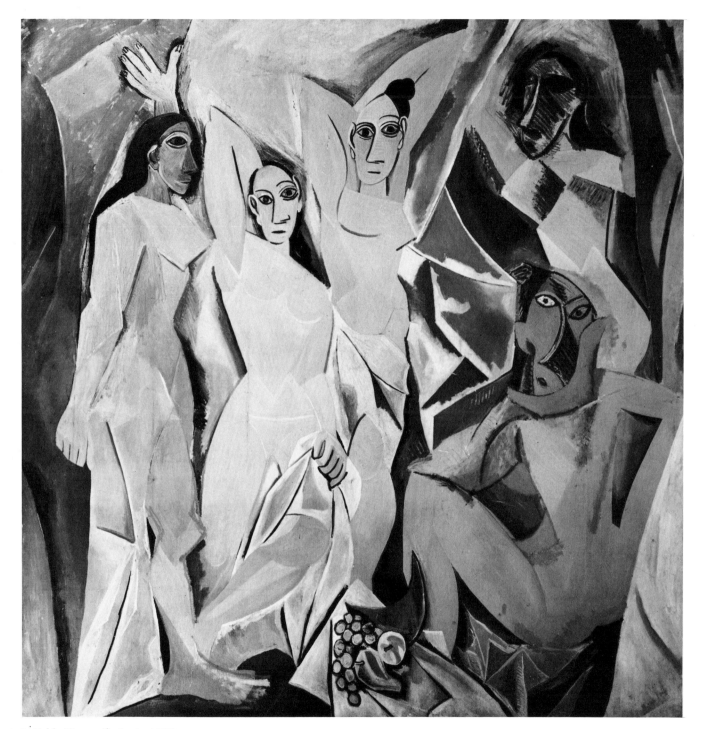

7. Pablo Picasso (b. Spain, 1881)
The Maids of Avignon (Les Demoiselles D'Avignon), 1907
Oil on canvas, 96" x 92"
Collection, The Museum of Modern Art, New York, N.Y.
Acquired through the Lillie P. Bliss Bequest.

18

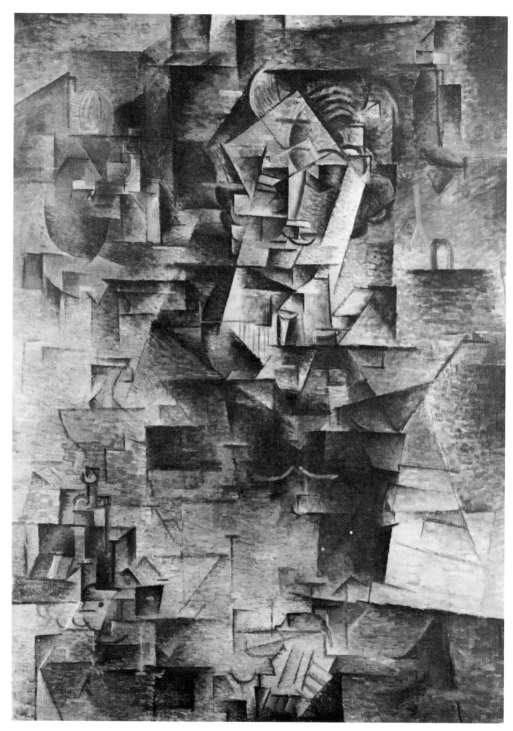

8. Pablo Picasso (b. Spain, 1881)
The Portrait of Daniel Henry Kahnweiler, 1910
Oil on canvas, 39⅝" x 28⅝"
Courtesy of The Art Institute of Chicago, Chicago, Ill.
Gift of Mrs. Gilbert W. Chapman.

portrait of his son (see first page, color section). True to Cubism, the painting is not an imitation of nature. Instead, Picasso has fragmented a natural form into its geometric basics and put these parts back together into a unified design. All parts are comprehended at once.

This independent attitude of the Cubists reflected their tenet that the artist was not a camera to record or to report on nature but a person especially endowed to be creative and inventive. The very perfection of the camera itself became an influence, one which turned these artists away from representation to invention and increasing abstraction. Contemporary science, especially the ideas of some mathematicians, also influenced these painters. Cubist paintings have a unity of time and space which calls to mind the theory of the fourth dimension. The *Maids* (Figure 7) and the Kahnweiler portrait (Figure 8) both reveal this. All views are comprehended at one glance instead of in sequence. The newly "discovered" African sculptures admired by the Cubists display comparable shapes, simplified and almost geometric. Art could and did forge ahead in many new directions.

Two still-life compositions, one by Juan Gris (Figure 9) and one by Georges Braque (Figure 10), show further instances of Cubism and the preoccupation with design of an increasingly two-dimensional sort. Greater simplification of shape made painting even more abstract. Color and texture came to be important in themselves. While Gris's composition is a painting, Braque's is a collage. Collage (*pâpier collé*) first appeared in 1912 and became a significant expression further freeing the artist by giving him new materials. Paper and other materials were substituted for the color and texture of paint. Materials formerly excluded from art became essential to it and made it even more creative. While a Cubist collage might refer to some real objects, such as a still-life group, its very elements (paper, etc.) had real existences of their own as well. These materials could be applied freely to form their own design while at the same time they carried color and perhaps texture reference to the objects of the still life.

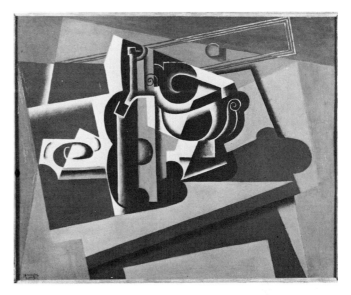

9. Juan Gris (Spanish, 1887–1927)
Still Life, February 1917
Oil on panel, 28¾" x 36³⁄₁₆"
The Minneapolis Institute of Arts, Minneapolis, Minn.
The John R. vanDerlip Fund.

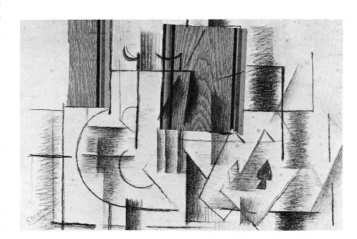

10. Georges Braque (French, 1882–1963)
Nature Morte (Still Life), ca. 1905–1909
Collage–black and white drawing, 11⅝" x 18⅛"
Los Angeles County Museum of Art, Los Angeles, Cal.
The Mr. and Mrs. William Preston Harrison Collection.

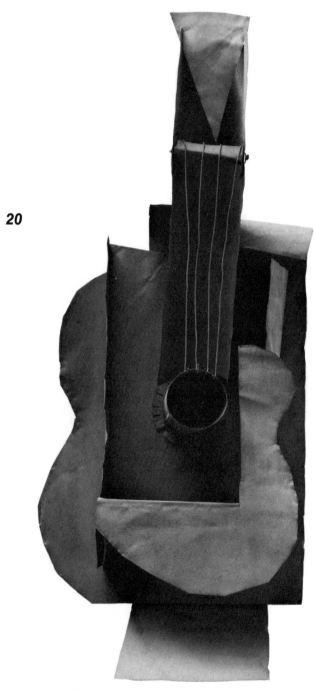

Picasso's *Guitar* of 1911–1912 (Figure 11) represents quite a logical development out of the collage compositions of this period. Though it might be termed a three-dimensional collage (or assemblage), it is a construction. Formed from scrap sheetmetal and wire, it is rather crude. However, it and others like it done by Picasso at this time are all significant for the later interest in scrap material and other "nonart" materials used by many artists. As in the case of the collages, the old junk materials take on new meaning and their aesthetic values—color, texture, shape, and line—become more important than their original function and in fact replace it.

Fernand Léger also came under the influence of Cubism. His compositions have natural forms which have been reduced to their geometric equivalents but are rather shallow and therefore relate to the two-dimensional surface of the painting (see second page, top left, color section). The outline is emphatic and tends to add to the flatness as well as to the design quality. Colors are simple but harsh and the forms seem almost metallic and machined, very much a part of the industrial world of the twentieth century. Léger not only spent some time in the United States; his work also became known here through exhibitions in New York City.

Max Weber is one of the American painters to come under the direct influence of the new developments in European art during the early twentieth century. During 1905–1908 he lived in Paris and for a time studied with Matisse there. The *Figure Study*, 1911 (Figure 12), suggests in its abruptly twisted two-dimensional arrangement this contact with Matisse, reminiscent of the latter's nude studies of *ca.* 1904. However, Cubism appears there, too, in the dull greyish colors, in the geometrically translated forms, in the blending of the figure with its surroundings, and in the making of a new unity not based on nature.

The importance of Morgan Russell should also be noted. By 1913, along with another American in Paris, Stanton Macdonald-Wright, Russell made a statement which gave rise to Synchronism. The concern of Synchronism was color: the creation of truly abstract compositions with arrangements of color (Figure 13) instead of the description of real things. These arrangements were such that the colors intensified, or else modified each other according to their tones and the extent of area covered by each. These colors could, and did, create effects of shape (geometric in derivation for Russell),

11. Pablo Picasso (b. Spain 1881)
Guitar, 1911–1912
Sheet metal and wire, 30½" x 13¾" x 7⅝"
Collection, The Museum of Modern Art, New York, N.Y.
Gift of the artist.

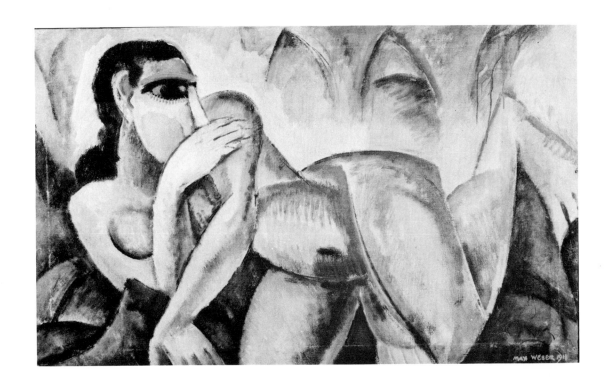

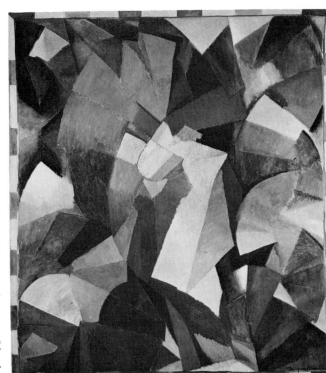

(Above)
12. Max Weber (American, b. Russia 1881–1961)
Figure Study, 1911
Oil on canvas, 24" x 40"
Albright-Knox Art Gallery, Buffalo, N.Y. C. W. Goodyear Fund.

(Right)
13. Morgan Russell (American, 1886–1953)
Synchromy in Orange: To Form, 1913–1914
Oil on canvas, 135" x 123"
Albright-Knox Art Gallery, Buffalo, N.Y.
Gift of Seymour H. Knox

movement, and space. The studies of optics by Charles Blanc and Hermann Helmholtz, Chevreul's theory of simultaneous color contrast, and Rood's theory concerning the equivalence of color and musical tones all influenced their work. The publications of these four men were all available and obviously of the greatest importance.

Another American, Charles Demuth (1883–1935) became fascinated during his Parisian sojourn with the possibilities opened up by Cubism. In *My Egypt* (see second page, top right, color section), painted in 1927 using a view of his hometown, Lancaster, Pennsylvania, he developed designs with a new order based on geometric forms. He introduced lines going at various angles to the surface, creating planes out of the space and light surrounding the buildings. Demuth's is a rather inventive and imaginative version of analytical Cubism, a far cry from the description of space used in *The Annunciation* by Romano (Figure 3).

On the other hand, Stuart Davis (American, 1894–1964) developed a style more akin to the collage phase of Cubism. *Owh! in San Pao* (see second page, bottom, color insert), 1951, shows his interest in color for its own sake and his two-dimensional emphasis. Any depth comes from the overlapping of one plane of color with another. There are the words and areas of color forming geometric figures which become the equivalents of things or places. In their organization they become a statement of an experience. The resulting composition suggests cut paper pasted together.

Although Cubism was essentially concerned with painting and pictorial expression, Picasso and others explored its possibilities in sculpture. The bronze *Head of a Woman* (Figure 14), *ca.* 1909, represents analytical Cubism comparable to the portrait of Kahnweiler. The head, as Picasso portrays it, is made up of masses, and each mass has distinct surfaces. The emphasis on these basic masses helps to relate them to each other and to the surrounding space. The result is a breaking up of the head into components which act together and in juxtaposition to make a three-dimensional design. The technique suggests direct working in clay made permanent by bronze casting. In the *Guitar* construction, or assemblage (Figure 11), Picasso has developed something midway between collage and sculpture. While it resembles collage in its flatness and emphasis on materials, it also resembles relief sculpture with its different levels and shape references. Somehow the separate pieces

22

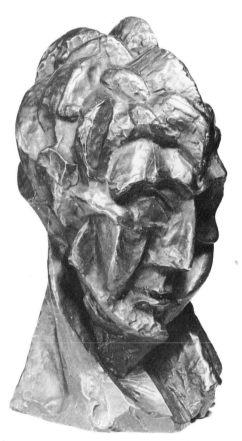

(Above)
14. Pablo Picasso (b. Spain, 1881)
Head of a Woman, ca. 1909
Bronze, 16¼" x 9" x 10¼"
Albright-Knox Art Gallery, Buffalo, N.Y.
Edmund Hayes Fund.

(Right)
15. Constantin Brancusi (Roumanian, 1876–1957)
Bird in Space, 1925
Polished bronze, marble base, 49¾" high
Philadelphia Museum of Art, Philadelphia, Pa.
The Louise and Walter Arensberg Collection, '50-134-14.
Photograph by A. J. Wyatt, staff photographer.

of metal refer to surface and mass and space in a sculptural way. It goes a step beyond *Head of a Woman* (Figure 14) in freedom of surfaces.

Moving further into abstraction and getting down to the geometric basis of natural forms, Constantin Brancusi has also created pure three-dimensional design. The *Bird in Space* (Figure 15) of 1925 effectively expresses the essence of the bird's graceful form which becomes more graceful as it soars through the air. *Bird in Space* unites the bird with the idea of flight. The beauty of its form is enhanced by the smooth sleek surface of the polished bronze. Brancusi transferred the almost machined perfection of the model to the bronze in the casting.

Other contemporaries of Picasso also carried art toward the ultimate expression of Cubism, namely, complete abstraction, or the nonobjective. Their work served as stepping stones to further developments in the twentieth century. Wassily Kandinsky, a Russian artist working in Paris, continued an interest in color not unlike the Expressionist work of Vincent van Gogh or the Fauve paintings of André Derain and Matisse. Like the Cubists, he developed an art that was not representational (Figure 16).

Painters such as Vincent van Gogh and André Derain and other Fauvists contributed significantly to twentieth-century colorists. Vincent van Gogh made his painting an outpouring of his emotional reaction to and involvement with the subject (see third page, color section). During the last few years of his life in Southern France, van Gogh responded to the sunlight and color of the area and painted freely and directly on the spot. The urgency of his reaction finds expression in the thickness of the paint, its vivid and often contrasting colors which effectively suggest rather than describe his feelings about the subject. He communicates his own turmoil in the way he translates everything into tortuous lines and contorted shapes. Van Gogh's was a subjective statement.

André Derain, like his Fauvist colleagues, responded to the colors of things around him, especially in landscape. He spread the paint on in broad areas of color, color which was far brighter than that observed, color which was pure and unmixed. His compositions are flat and two-dimensional, an effect enhanced by the strong outline he used. The forms are much simplified and only significant ones are included. In these paintings, *ca.* 1906–1908, he spans the time from the expressionism of some Post-Impressionists to the start of Cubism.

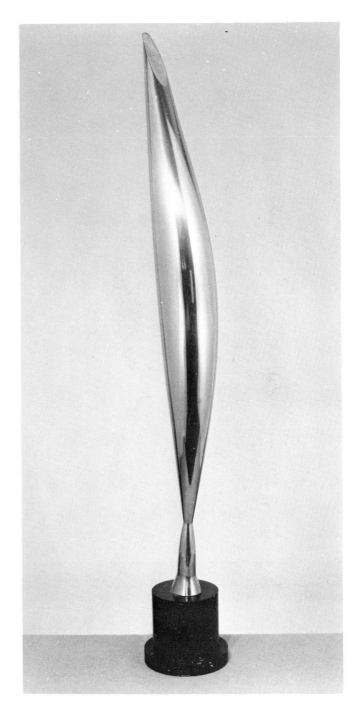

23

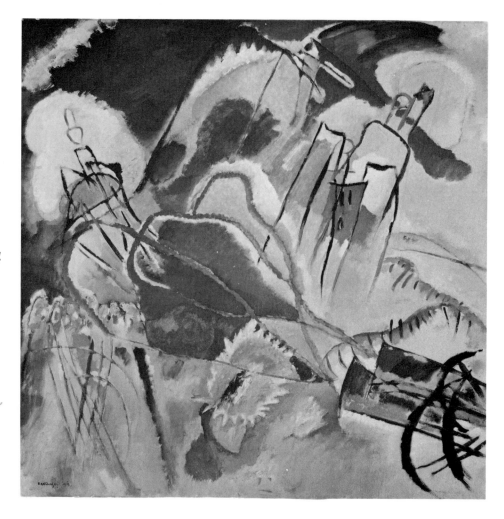

However, Kandinsky differed from either Vincent van Gogh or the Fauves in developing compositions which in no way depicted the real world. His compositions became totally nonobjective (Figure 16). He organized color in free masses and lines which were rhythmic and dynamic statements of the essence of experience and which evoke an emotional response from the viewer. While the viewer's response might be similar to that expressed by the artist, it need not be. Kandinsky entitled his paintings merely *Composition* or *Improvisation*. Any attempt to relate them to familiar objects is futile because they must be seen in terms of color organization. He had very definite ideas about arranging his paintings and found a common ground with music in rhythm and sound–color relationships.

This nonobjective type of painting appeared elsewhere at the same time. Piet Mondrian, a Dutch painter who had been in Paris in 1911 and influenced by Cubism, was associated with the group in Holland known as "De Stijl." These artists, who were dedicated to an art of nonrepresentation with a geometric basis, worked actively as a group during the years 1917–1931. Their painted compositions organized pure color into two-dimensional and rectangular forms. Mondrian arrived at his final style through simplifying trees and buildings (Figure 17; *cf.* Figure 18) into geometric areas of color and line. He and the others made use of the working methods of the modern scientist and technician: the De Stijl method was impersonal, used an abstract language, and in some cases even had a formula for predictable results.

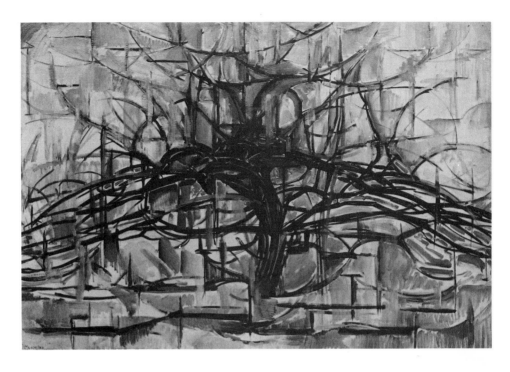

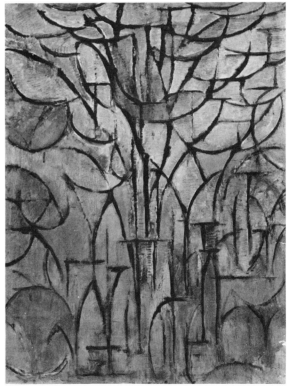

(Left)
16. Wassily Kandinsky (Russian, 1886–1944)
Improvisation #30 (Warlike Theme), 1913
Oil on canvas, 43¼″ x 43¾″
Courtesy of The Chicago Art Institute, Chicago, Ill.
Arthur Jerome Eddy Collection.

(Above)
17. Piet Mondrian (Dutch, 1872–1944)
Horizontal Tree, 1911
Oil on canvas, 29⅝″ x 43⅞″
Collection of Munson-Williams-Proctor Institute, Utica, N.Y.

(Right)
18. Piet Mondrian (Dutch, 1872–1944)
Tree, ca. 1912
Oil on canvas, 37″ x 27½″
Museum of Art, Carnegie Institute, Pittsburgh, Pa.
Patrons Art Fund.

26

(Above)
19. Ben Nicholson (British, b. 1894)
Still Life, 1950
Oil and pencil on canvas, 25½" x 49"
Courtesy of The Detroit Institute of Arts, Detroit, Mich.
Gift of the Friends of Modern Art.

(Left)
20. Ben Nicholson (British, b. 1894)
March 21, 1952 (Ides of March), 1952
Oil, 36" x 30"
The Toledo Museum of Art, Toledo, Ohio.
Gift of Edward Drummond Libbey.

By placing rectangular areas of primary color among the white rectangles and by means of the accenting grid of black strips, Mondrian created effects of mass and rhythm through repetition. He also created a sense of depth by advancement or recession of one color with respect to another through contrast of intensity and even size. *Broadway Boogie Woogie* (see fourth page, color section), painted during his few years in New York, thus expressed the vitality and tempo of the city.

While in London, Mondrian influenced the Englishman, Ben Nicholson. Nicholson created very simple abstract compositions geometrically based (Figures 19 and 20), often as painted bas-reliefs. The Swiss-born American Fritz Glarner has been similarly influenced (Figure 21). Using the primary colors interspersed with white areas, he created a sort of woven composition of irregular and narrow rectangles vertically oriented. They have no surface texture but the color patches appear to overlap and to advance and recede in shallow depth.

Burgoyne Diller, an American artist, became a veritable disciple of Mondrian. He developed only three themes—a free element, one generated by continuous lines, and one submerged in activity by a multitude of lines. Within this he found endless variety which he composed with carefully worked-out proportion. The *Second Theme* (Figure 22) of 1938–1940 is a rather typical Diller work.[7] A grid of bands forms rectangles between the bands. This combination forms his second theme. The bands vary in width and length and most of them go to the edge of the canvas so that the white areas between them seem to be without boundary. The bands themselves seem to move beyond the limits of the canvas, too. The proportions, though carefully considered, were based on visual satisfaction and are not mathematically computed. At the time that Diller was working out these very abstract nonobjective paintings, American artists were painting little if any of this sort of work. During these years, Diller also worked on WPA projects in New York, directing mural work and doing some himself. His murals in New York were said to have resembled this very painting, *Second Theme* (Figure 22).

During the early years of the twentieth century, especially 1913–1922, Russian Suprematism and Constructivism provided more evidence that art did not need to

7. Larson, Philip: *Burgoyne Diller: Paintings, Sculptures, Drawings*. Minneapolis, Minnesota: Walker Art Center, 1971.

(Left)
21. Fritz Glarner (American, b. Switzerland 1889–1972)
Relational Painting #89, 1961
Oil on canvas, 77" x 46¾"
University of Nebraska Art Galleries, Sheldon Art Gallery,
Lincoln, Neb. F. M. Hall Collection.

(Above)
22. Burgoyne Diller (American, 1906–1965)
Second Theme, 1937–1938
Oil on canvas, 30⅛" x 30"
The Metropolitan Museum of Art, New York, N.Y.
George A. Hearn Fund, 1963.

be representational. Both schools had grown from Cubism's influence. As a Suprematist, Kasimir Malevich was concerned with the basic elements in the following order, indicating the importance of each: the square (the epitome of man's mastery over nature), the circle, the triangle. From these forms, many compositions (Figure 23) could be developed in clear color against white.[8] In 1913, Malevich exhibited his famous black square made by lead pencil on a white background. When the critics and the public first saw it, they moaned, "Everything we loved is lost: we are in a desert. . . . Before us stands a black square on a white ground." By Suprematism, Malevich means, "the supremacy of pure feeling or perception in the pictorial arts." "In exhibiting the black square he was not exhibiting an empty square but the experience of non-objectivity." [9] The work of Malevich and El Lissitsky paralleled that of De Stijl and mingled with it after World War I.

Russian Constructivism, exemplified by Tatlin, Rodchenko, and El Lissitsky, grew out of Cubist collage. Their sculpture was composed in a similar way. They combined pieces of wire, glass, and sheet metal, making free and open arrangements. Constructivist sculpture was the opposite of the nature-derived masses of carved wood or even bronze casts which had formed the basis of sculpture heretofore. It was Tatlin who invented the term "Constructivism" to distinguish his built-up work from sculpture which was carved or cast.

In 1920, Naum Gabo, an American born in Russia in 1880, together with his brother Antoine Pevsner, published a manifesto in Russia to explain that their sculptures were not modelled but put together in space, using space as a positive element (Figure 24). They concerned themselves not only with the outer aspects of nature but the inner forms as well. They were the first to use transparent materials (Figure 25), as important means to achieve their spatial compositions.

These expressions of the Russian artists are important not only for their time, but for later developments. Like the works of the Cubists, De Stijl, and the other non-objective artists, they were intermediate steps toward new areas for both painting and sculpture. The United States had developed with a heritage derived from many foreign sources. These influences contributed to a rich culture reflected in artistic activity of the twentieth cen-

23. Kasimir Malevich (Russian, 1878–1935)
Suprematist Composition (Airplane Flying), 1914
Oil on canvas, 22⅞" x 19"
Collection, The Museum of Modern Art, New York, N.Y.

8. Barr, Alfred H., Jr.: *Cubism and Abstract Art.* New York: Arno Press (reprint), p. 122.
9. *Op. cit.*: p. 124.

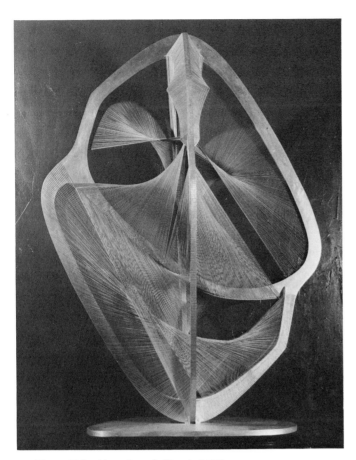

24. Naum Gabo (American, b. Russia 1890)
Linear Construction No. 4, ca. 1959–1961
Aluminum, 39" high
Smithsonian Institution: Joseph H. Hirshhorn Museum and
Sculpture Garden, Washington, D.C.

25. Naum Gabo (American, b. Russia 1890)
Construction in Space (working model for the Crystal), 1937
Plastic (Rhodoide), 9" high
Property of Vassar College Art Gallery, Poughkeepsie, N.Y.
Gift of Mrs. Gilbert Harrison (Nancy Blaine, '40) 1938.

tury. From time to time American artists have made their own unique contribution, a phenomenon dramatically demonstrated toward the beginning of the second half of this century.

The early years of the twentieth century in the United States showed many symptoms of change. These years make a story by themselves. "The Eight," under the leadership of Robert Henri, took their subjects for paintings from their own surroundings in New York. Since these subjects included the backyards and alleys of the city, the artists came to be known as the Ashcan School. Such ordinary and unlovely subjects were revolutionary in the eyes of the traditionally minded. Opposed to the American Academy, the Eight preferred "life" to "art" thus earning their other name, "The Revolutionary Black Gang."

The photographer Alfred Steiglitz exhibited photographs and paintings and sculpture at 291 Fifth Avenue, New York. Here, as early as 1908, he had shown the work of the French sculptor Rodin. In 1911 he introduced the work of Picasso and Brancusi. Steiglitz also showed the work of the avant-garde Americans, among them, Max Weber. The art world was made aware of new developments through "291."

Other American avant-garde artists included George Bellows, Walt Kuhn, and Arthur B. Davies, who belonged to a group interested in sponsoring the independent attitude of modern art. This group formed the Association of American Painters and Sculptors, and their chief activity was to organize an exhibition that would foster new art which the galleries refused to recognize and show. Their efforts resulted in the Armory Show of 1913 which opened first in New York, then in Chicago, and finally in Boston. The Armory Show rocked the art world and stunned the public. For many it was their first encounter with the European and American moderns and they came on these artists quite unsuspecting. The exhibition had a lasting effect on American art.

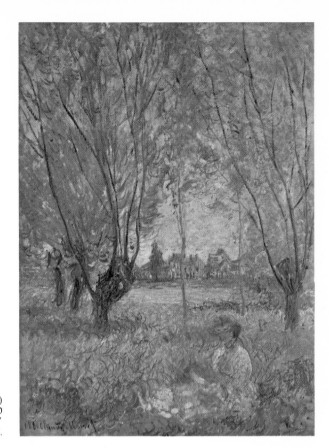

Claude Monet (French, 1840–1926)
Woman Seated Under the Willows, 1880
Oil on canvas, 31 7/8" x 23 5/8"
Chester Dale Collection, National Gallery of Art, Washington, D.C.

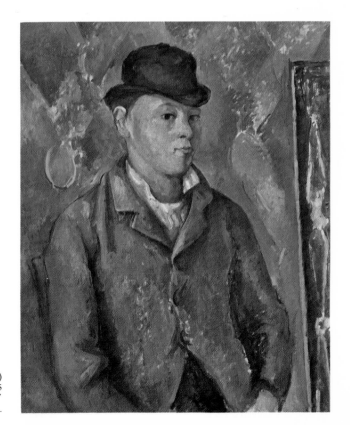

Paul Cézanne (French, 1839–1906)
The Artist's Son, Paul, 1885
Oil on canvas, 25 3/4" x 21 1/4"
Chester Dale Collection, National Gallery of Art, Washington, D.C.

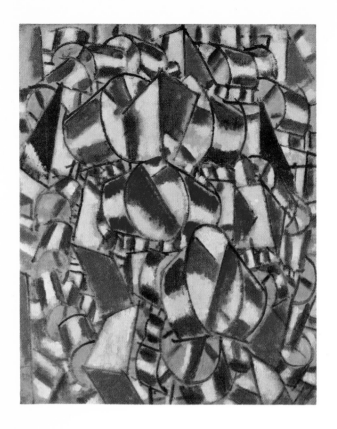

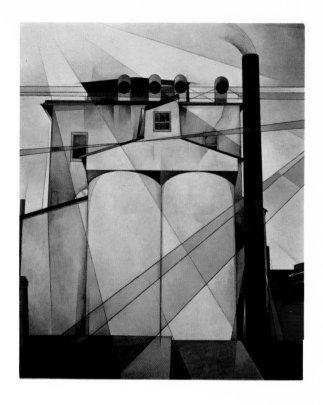

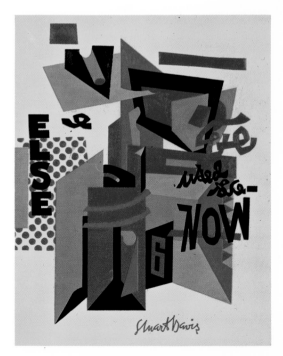

(Above, left)
Fernand Léger (French, 1881–1955)
Contrast of Forms, 1913
Oil on canvas, 39½" x 32"
Collection, The Museum of Modern Art, New York, N.Y.

(Above, right)
Charles Demuth (American, 1883–1935)
My Egypt, 1927
Oil on composition board, 35¾" x 30"
Collection, Whitney Museum of American Art, New York, N.Y.

(Right)
Stuart Davis (American, 1894–1964)
Owh! in San Paõ, 1951
Oil on canvas, 52¼" x 41¾"
Collection, Whitney Museum of American Art, New York, N.Y.

Vincent van Gogh (Dutch, 1853–1890)
Houses at Auvers, 1890
Oil on canvas, 23⅞″ x 28¾″
The Toledo Museum of Art, Toledo, Ohio.
Gift of Edward Drummond Libbey.

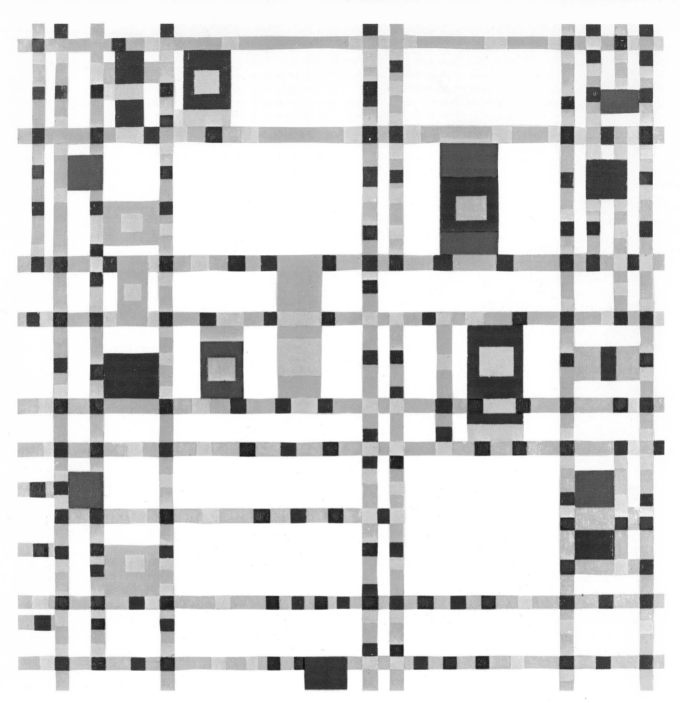

(Above)
Piet Mondrian (Dutch, 1872–1944)
Broadway Boogie Woogie, 1942–43
Oil on canvas, 50″ x 50″
Collection, The Museum of Modern Art, New York, N.Y.

(Right, top)
Hans Hofmann (American, b. Germany 1880–1966)
White Space, 1950
Oil on canvas, 29″ x 37½″
Washington University Gallery of Art, St. Louis, Missouri.

(Right, bottom)
Archile Gorky (American, b. Armenia 1905–1948)
The Liver is the Cock's Comb, 1944
Oil on canvas, 72″ x 98″
Albright-Knox Art Gallery, Buffalo, N.Y.
Gift of Seymour H. Knox.

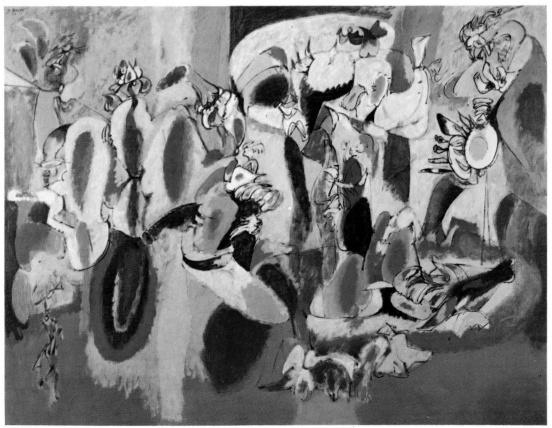

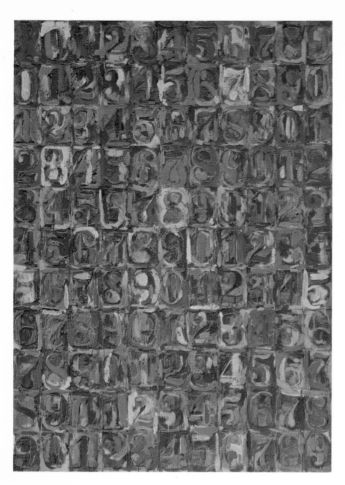

(Left)
Jasper Johns (American, b. 1930)
Numbers in Color, 1959
Encaustic paint on newspaper on canvas, 66½″ x 49½″
Albright-Knox Art Gallery, Buffalo, N.Y.
Gift of Seymour H. Knox.

(Below, left)
David Smith (American, 1906–1965)
Hudson River Landscape, 1951
Steel, 75′ long
Collection, Whitney Museum of American Art, New York, N.Y.

(Below, right)
Richard Stankiewicz (American, b. 1922)
Kabuki Dancer, 1956
Steel and cast iron, 80½″ high
Collection, Whitney Museum of American Art, New York, N.Y.
Gift of the Friends of the Whitney Museum of American Art.

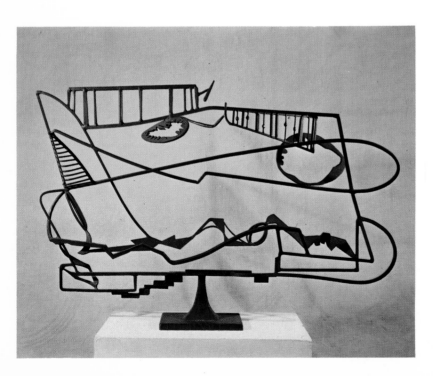

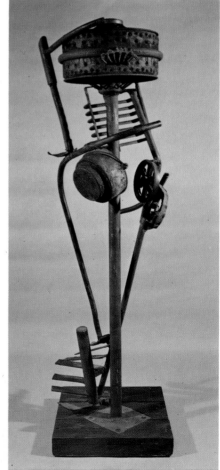

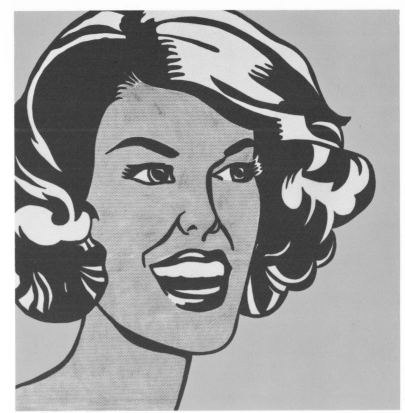

(Right)
Roy Lichtenstein (American, b. 1923)
Head, Red and Yellow, 1962
Oil on canvas, 48" x 48"
Albright-Knox Art Gallery, Buffalo, N.Y.
Gift of Seymour H. Knox.

(Below)
Claes Oldenburg (American, b. Sweden 1929)
Giant Hamburger, 1962
Painted sailcloth stuffed with foam rubber,
ca. 52" x 84"
Collection, Art Gallery of Ontario, Toronto, Canada.

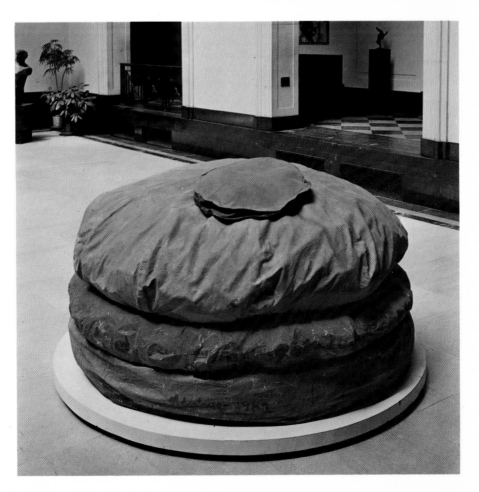

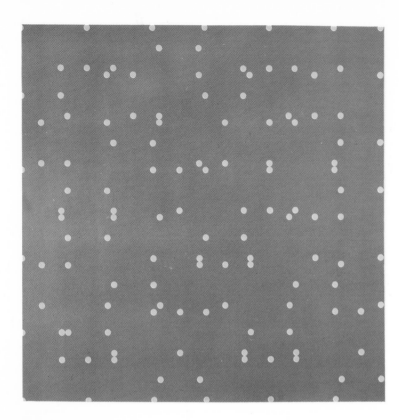

(Left)
Larry Poons (American, b. Tokyo 1937)
Orange Crush, 1963
Acrylic on canvas, 80" x 80"
Albright-Knox Art Gallery, Buffalo, N.Y.
Gift of Seymour H. Knox.

(Below)
Peter Young (American, b. 1940)
Number 22—1968, 1968
Acrylic on canvas, 108" x 96"
Albright-Knox Art Gallery, Buffalo, N.Y.
Members' Council Purchase Fund.

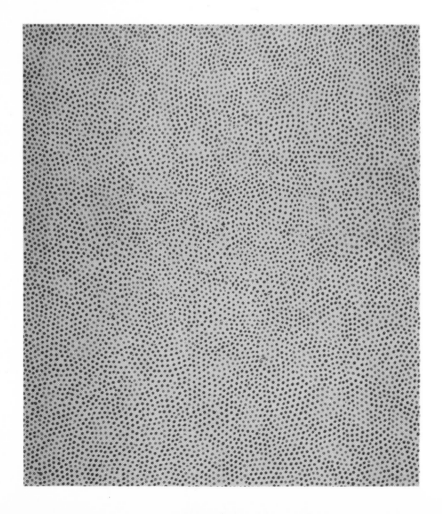

Part Two

DEVELOPMENT OF CONTEMPORARY ART

Abstract Expressionism

We have seen how Impressionism constituted a modern revolutionary movement. Those artists concentrated on the fleeting moment, using pure color in dabs, and painting on the spot. The Impressionist painter was as objective in his way as the camera can be in its way in recording what is in front of it (see first page, color section).

On the other hand, Expressionism, an early twentieth-century movement, was purely subjective. The artist painted his feelings or emotions about an observed or experienced subject. The Expressionist concerned himself with interpreting rather than with describing his subject (see third page, color section).

Abstract Expressionism, that American phenomenon, became the most revolutionary of these three modern groups. The Abstract Expressionist painter used color to express his internal feelings, to be sure, but also involved himself in the very activity and process of painting. The organization of the paint on the canvas is a development in which each step depends upon the prior one and does not result from any advance planning. Such a free, personal statement objectifies the artist's emotions in terms of the paint, its color and texture. The resulting painting moves over the surface of the canvas without the usual focal point and manages to involve the viewer who experiences the colors as they have meaning for him. The viewer who merely glances, shudders, and walks away has not given the painting a chance to communicate on its own terms.

It was not until the 1940s that this new and peculiarly American development, with some roots in the not-too-distant past, appeared. We trace here Abstract Expressionism, as it came to be known, through the work of Jackson Pollock, Franz Kline, Willem de Kooning, Hans Hofmann, Sam Francis, and Mark Rothko. It is interesting to speculate whether it would have appeared at all if the Romantic revolt of the nineteenth century had not occurred and set the stage for Impressionism and all that appeared subsequently. Abstract Expressionism was an influential force for about fifteen years, the period between 1945 and about 1960.

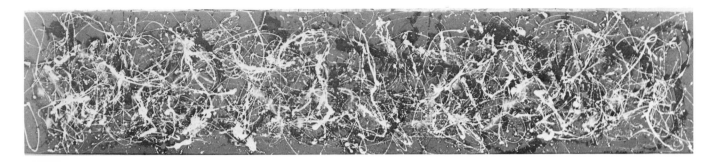

26. Jackson Pollock (American, 1912–1956)
No. 2, 1949
Oil duco and aluminum paint on unsized canvas, 38⅛" x 15' 9½"
Collection of Munson-Williams-Proctor Institute, Utica, N.Y.

34

During the years after World War II in the United States, a number of artists, many having been kept alive by the Work Progress Administration (WPA) projects, were attracted to New York. Among them in the city were artists who had fled Europe and became influential although the lengths of their visits varied.[10] Archile Gorky came as early as 1920. In 1926 William de Kooning left Holland for the United States, eventually settling down in New York. Hans Hofmann arrived in 1930 and Josef Albers came in 1933. Léger made a visit to the United States late in the 1930s to do a mural, a project never accomplished. After a few years he returned to teach for a while at Yale and also at Mills College. Lazlo Moholy-Nagy came about one year later, in 1937. The Dutchman, Mondrian, had been living in Paris for some time before going to London in 1938 and then two years later, to escape the war, he took refuge in New York, living there until his death. Naum Gabo came over in 1946. While Marcel Duchamp made the first of many visits in 1915, it was not until 1955 that he became a permanent resident and citizen. Others too have exerted their influence in this way—André Breton, Max Ernst, Matta, Kurt Seligmann, Yves Tanguy, to mention some—and all of them were involved with Surrealism.

Many of these Europeans exhibited their work in New York and some taught in various schools and universities. They brought with them from Europe the most recent attitudes. In all cases they had been through the experience of the reactions to Impressionism, namely Post-Impressionism, Expressionism, then Cubism and those developments it prompted, especially the Non-objective. While abstraction was a major factor, Surrealism was of almost equal importance. Perhaps Gorky, among the Surrealists, had the most significance for the peculiarly American development, Abstract Expressionism.

After Gorky came to the United States he worked on WPA projects. His own work belonged to the Surrealist tradition. In fact, he exhibited in Surrealist shows and knew the work of some of the great Surrealists like the Spaniard, Joan Miró, and the Frenchman, André Breton. For a time he shared a studio in New York with Willem de Kooning who became one of the foremost Abstract Expressionists.

Surrealism is very complex. Yet underlying its varied manifestations is a concern with the world of the mind and the subconscious. This interest was frequently expressed by the artist through a private language: his own use of color and line and invented shapes which exist only in a world of their own. An artist could easily let his brush or other painting tool be guided by a force derived from the subconscious, a sort of automatic expression. Surrealist forms are inventive and unfamiliar and frequently amorphous, lacking defined form and having no fixed place in space. The very gesture producing the painting was at least as important as the result.

Gorky developed a style of free colorful forms suggesting organic derivation. In *The Liver is the Cock's Comb* (see fifth page, bottom, color section), these forms

10. Rose, Barbara: *American Art Since 1900. New York:* Praeger, pp. 148 and 157.

based on human anatomy tend to be indefinite and to appear to be floating about or else held in suspension. While some of the forms are explicitly derived from the human anatomy, others are more symbolic and even cryptic. The imaginative quality and freedom reminds one of the manner of composition developed by Miró, Matta, and even Masson, Surrealists who influenced Gorky. And then something of Gorky's painting is echoed in the work of Jackson Pollock, for one.

With Pollock, American painting entered into a new phase. First of all, he combined abstraction with free use of color to make a very inventive composition which came from his inner being. Like Kandinsky's work, Pollock's work was an emotional outpouring. But his painting was not stimulated by tangible experience. Great size soon became necessary. The activity of making the painting was of primary importance. Wanting ultimate freedom, Pollock developed the method of dribbling and pouring paint on unsized and unstretched canvas. Possibly his experience with American Indian sand paintings in the Southwest—the Indian artist poured colored grains of sand to make a picture—influenced his unorthodox approach. Perhaps, prompted by the Cubists, he introduced sand and other "foreign" matter into the paint to further emphasize surface effect. One cannot view a Pollock painting for long without sensing his physical activity—how he moved around the painting freely applying the paint from all directions, each color at the appropriate moment. While a painting such as *No. 2* (Figure 26) seems to be the result of a great frenzy of activity in a short period of time, it shows his ability to make the paint do what he wanted it to, when he wanted, building layers of fine threads of color and swirling ribbons, making flecks and puddles of color. The product is a richness of color, carefully controlled, which envelops the viewer and entwines him in a world of pure form, space, and movement. The bigger the painting, the more effective it is. One composition, in the collection of Mr. and Mrs. Ben Heller, measures 110" x 211", or over 9 feet by over 16 feet. Painting *No. 2* measures 38½" x 15' 9". Harold Rosenberg called this manner of painting "action painting." Abstract Expressionism is another term for it.

Franz Kline developed his own manner of action painting or Abstract Expressionism. Interested in his urban surroundings of New York, his early work recorded it rather factually. By 1950, he began free brush sketches which were abstract derivations of buildings and people.

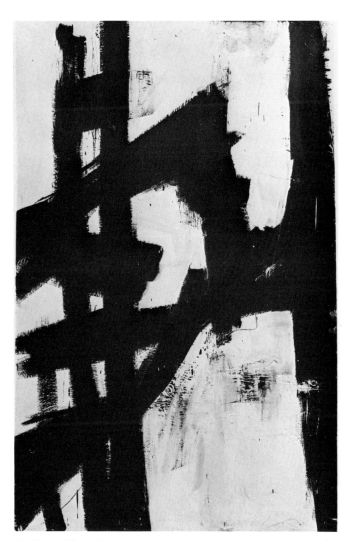

27. Franz Kline (American, 1910–1962)
New York, 1953
Oil on canvas, 79" x 50"
Albright-Knox Art Gallery, Buffalo, N.Y.
Gift of Seymour H. Knox.

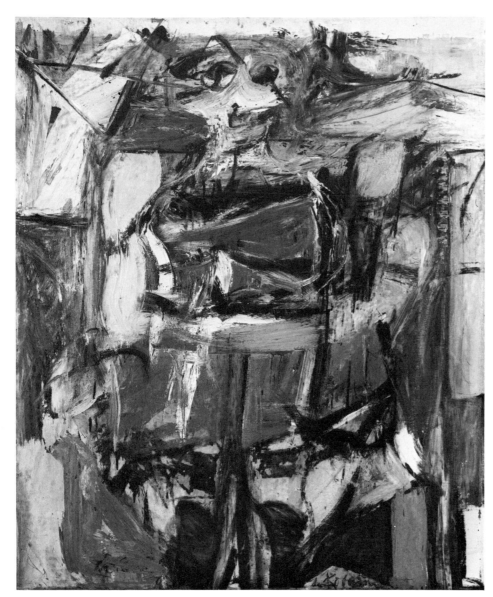

36

(Left)
28. Willem de Kooning
(American, b. Holland 1904)
Woman VI, 1953
Oil on canvas, 68½" x 58½"
Museum of Art, Carnegie Institute,
Pittsburgh, Pa.
Gift of C. David Thompson.

(Right)
29. Willem de Kooning
(American, b. Holland 1904)
Composition, 1955
Oil on canvas, 79⅛" x 69⅛"
The Solomon R. Guggenheim Museum,
New York, N.Y.

These quickly became broad startling strokes of black and white paint which in their crisscrossing and angular juxtapositions express the vitality of the city and its structures (Figure 27). He used duco house paint because it allowed him freedom and because it was cheap. The black and white areas interact in such a way that both are positive: one does not form the background for the other.

Even though Willem de Kooning shared a studio with Gorky for a time, he had no connection with Surrealism.

His concern for form and space was closer to Cubism than anything else. His compositions, reminiscent of the earlier analytical Cubist paintings, consist of forms taken apart, rearranged, and related to space. De Kooning takes his subjects from his environment and presents them in his own symbolic language of color and shape. The *Woman* series naturally caused great excitement and still attracts attention and invites reactions (Figure 28). A traditional and even sacred subject, de Kooning distorted it and made it more terrifying with the slashes of

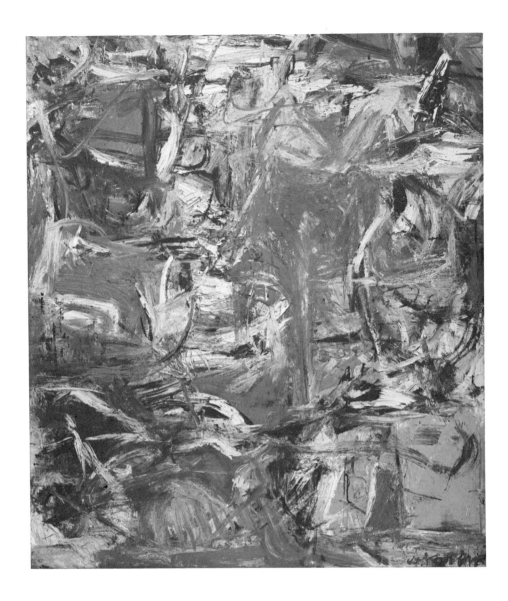

paint and rich rough texture. These brutal and harsh paintings use colors which are equally garish and shocking. If Picasso's *Maids* (Figure 7) were considered brutal, these are more so because they are so directly and freely rendered. They resulted from countless sketches, with many changes and paint scraped away and reapplied. In many cases some of the sketches have become incorporated into the paint, making a collage effect. All through this intense working period de Kooning exercised control and everything he did contributed to the conclusion he wanted. The result is vital and real in that it exists in terms of itself. The colors symbolize flesh and life and they complement forms which are distorted but vital. The surface of the painting *Composition*, 1955, (Figure 29), comes alive in the direction of the brushwork and the seeming rapidity of the application of the paint. Except for the widely different results, a certain similarity to van Gogh's work exists in the obviousness and urgency of the brushstrokes which suggest the deep involvement of each artist with his painting.

(Above)
30. Sam Francis (American, b. 1923)
Why Then Opened I, 1962–1963
Acrylic on canvas, 84" x 72"
Dallas Museum of Fine Arts, Dallas, Texas.
Gift of Mr. and Mrs. Algur H. Meadows and
the Meadows Foundation, Inc.

(Right)
31. Mark Rothko (American, b. Russia 1903–1970)
Red Maroons, 1962 #2, 1962
Oil on canvas, 79" x 81"
Contemporary Collection and Friends of the
Cleveland Museum of Art, Cleveland, Ohio.

Hans Hofmann had lived and taught in this country for four years before he founded his own school in New York in 1934. Consequently his influence has been considerable among American painters. His work is both abstract and expressionist. He considered his sort of painting to be the necessary balance to the banality of daily life. Hofmann's paintings consist of generously and freely applied areas of color in varying sizes (see fifth page, top, color section). Sometimes they are rectangularly organized, sometimes they are broadly linear. In either case the colors interact in hue and intensity, creating a tension over the surface as the colors advance or recede and vie with one another. They have a formality that seems to derive from Cubism and yet the quality of the colors shows pure expressionism. His most impressive compositions were done after he was sixty and they have a vigor and richness that is enviable.

One of the second generation of the Abstract Expressionists, Sam Francis, uses the images and spaciousness —created by free use of pure, thin colors—that have occupied him since he gave his attention to abstract or nonobjective statement. He began by daubing or spotting colors onto the canvas so that instead of blending they would become luminous, transparent layers. Francis then caused the colors to run over each other and this further enlivened the surface. Like Pollock's paintings they are all-over in organization and lack any focus. In time he has begun to open up his masses of colors to leave free areas of white canvas (Figure 30) which in no way become empty or static. Instead, the white areas prove sparkling vibrant foils for the colors which often cling around the edges or hover off to one side. These later paintings create a vital spaciousness.

Mark Rothko brought his paintings to a very simple state, essentially to one color and subtle variations of it.[11] He used unsized canvas so that the colors would bleed into the surface. The colors seemed to glow because he used a thin liquid mixture of paint which the white of the canvas enhanced. The picture surface was divided into two, sometimes three, horizontal areas (Figure 31). Rothko framed these areas of color with a related color which enhanced them by its very intensity. All the areas of color related to each other, and their subtle variations created spaciousness and even luminosity.

11. Hess, Thomas B.: "Rothko: a Venetian Souvenir." In *Art News*, Vol. 69, No. 7, November 1970, pp. 40, 72–74.

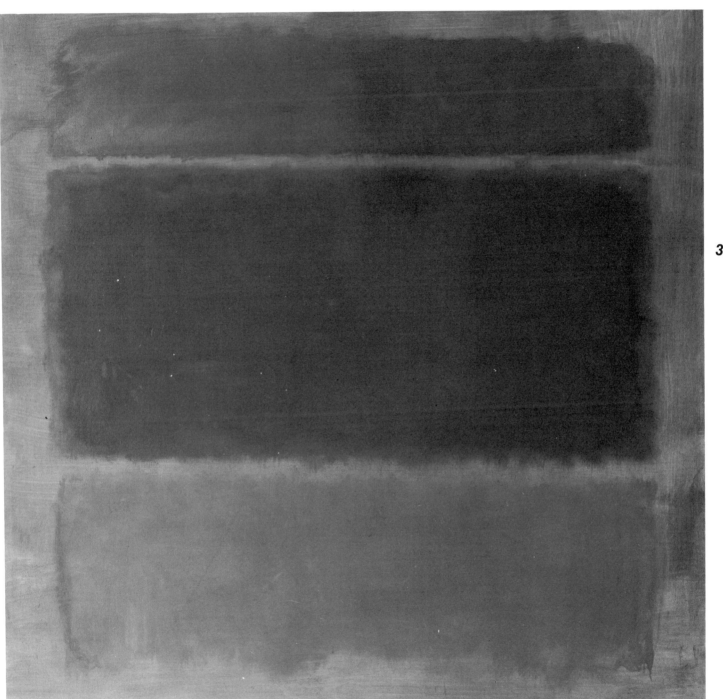

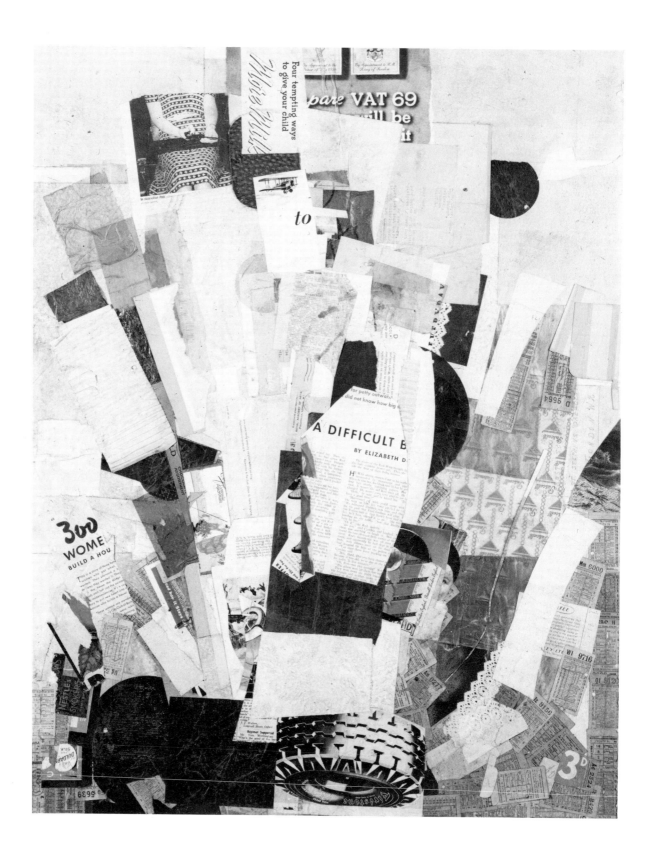

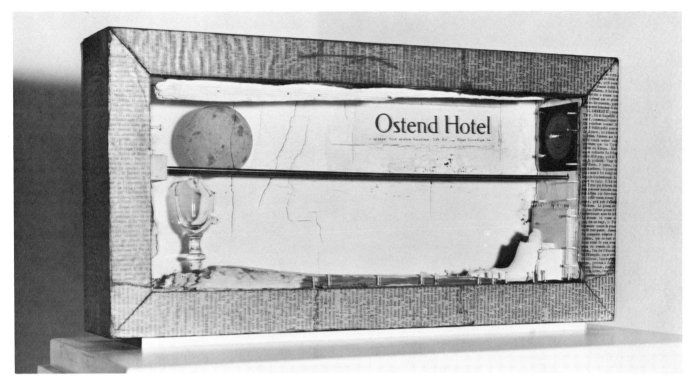

(Left)
32. Kurt Schwitters (German, 1887–1948)
Difficult, 1942–1943
Collage, 31¼" x 24"
Albright-Knox Art Gallery, Buffalo, N.Y.
Gift of the Seymour H. Knox Foundation, Inc.

(Above)
33. Joseph Cornell (American, b. 1903)
Hotel Ostend, ca. 1958
Variety of materials and found objects, 8" x 16½" x 3⅜"
Albright-Knox Art Gallery, Buffalo, N.Y.
Edmund Hayes Fund.

Assemblages / Constructions

Ever since the first Cubist collage appeared on the art scene, the idea continued intermittently in one form or another. The work of Kurt Schwitters, Joseph Cornell, Robert Rauschenberg, Jasper Johns, and Corrado di Marca-Relli is pertinent. Many other American artists, and Europeans, too, however, have been using collage as a means of expression, though not exclusively.

The fascination with and the possibilities of nonart materials captured the attention of Kurt Schwitters. His contact with Dada, an anti-art movement, influenced him greatly, and as early as 1919 he began to compose pictures with all sorts of scraps of paper and other materials. He even made three-dimensional arrangements with cast-off scraps of wood, sometimes painting them, and creating with them something of sculptural significance. (Since they were composed of junk, he called them "mertz," which means just that.) The composition, *Difficult* (Figure 32), is a late work but very typical: old tram tickets, candy papers, scraps of newspapers and magazine pages, in fact any cast-off junk at hand. Organized for interesting surface effect, these scraps are interspersed with pictorial items which have a narrative potential for the viewer. One is teased by the lady holding a gun and a milk ad juxtaposed with a whiskey ad. And then, what about that tire? Certainly Schwitters' work has been known to many artists, and in one way or another he has been an influence.

Joseph Cornell, an American artist easily overlooked, appears to have been very much in the art picture and familiar with art and the artists active in New York in the early 1930s. In fact, it was the Surrealist group that he knew. These European artists, among them Max Ernst,

were in the city and their work appeared in various exhibitions. Something of the mystery and poetry of Surrealism is in Cornell's work. He began with collages, then soon switched to boxes: small, shallow, and filled with "treasures"—scraps of all kinds, small goblets or other miniature objects, and cutouts from old engravings. Each box encloses its own world—things remembered perhaps, things of the imagination possibly. *Hotel Ostend*, 1957 (Figure 33) is haunting. A memory of a place visited on the beach? A place purely imaginary? Some of the mystery comes from the colors of the old newspapers, the grey-white and pale blue colors of the paint. In this particular box, the ball can roll from side to side but not of its own volition. It reminds the viewer of sandy beach, dull sky, and the worn, faded, painted wood of an old hotel.

Robert Rauschenberg's combines seem to be the American equivalent of Schwitters'. *Ace*, done in 1962 (Figure 34), is a product of the twentieth century from Cubism and on with its typical two-dimensionality and abstractness. Only in the twentieth century could an artist combine wood, metal, paper, cloth, cardboard with painterly areas. Cubist collage and Dada provided that possibility. The freely painted areas are reminiscent of Abstract Expressionism where the gesture and the process of painting are as important as the result. The objects attached are from the environment, and, in combination with the painted passages, they seem to refer to the viewer's surroundings as well as to create a new environment.

In *Numbers in Color* (see sixth page, top, color section), Jasper Johns has combined newspaper collage with encaustic paint. In this case, the pigments are in a wax emulsion and the paint so formed can be brushed on freely to enhance the basic pattern. The wax medium lends not only a soft and bumpy texture to the surface but also gives the colors a certain brightness. The paint in no way obstructs the newspapers which were torn to form the numerals 0 to 9. Like many of his contemporaries, Johns took his subject from everyday experience—what day do we live through without using and encountering numbers of some kind? Here he has made them into an intricate pattern based on sequences and enhanced by sequences of colors. The sequences themselves suggest the very contemporary computer.

After a number of years as a painter of pictures that tended toward the abstract, Corrado di Marca-Relli turned to collage by 1953. Increasingly, his paintings had

developed more and more surface texture through heavily laid on paint. To build a picture by laying on layers of canvas pieces came as a natural next step (Figure 35). While these compositions of pieces of painted canvas began as derivations from the human figure, they more recently have little if anything to do with that image. He has even more recently developed compositions, derived from the earlier painted canvas ones, of overlapping metal pieces riveted together. An interesting rhythm results from the surface texture and also from the flow of the edges of the material which curve or go straight and even angular.

These artists represent only a very few of those in contemporary times who have made use of the collage-type technique. The result is a great variety of inventive and creative statements which have considerably extended the possibilities for visual expression.

Both Schwitters (Figure 32) and Rauschenberg (Figure 34) used collage-type techniques which have become three-dimensional and truly sculptural. Here again, many recent American artists benefited from the early collages as well as from the constructed work of Picasso (Figure 11) and the Russian Constructivists (Figures 24 and 25). Sculptural design has consequently taken on a thoroughly new look. It is open and free in form, making use of a variety of materials. In addition, it no longer derives from human or animal forms as had traditional sculpture.

This change in sculpture came about not only through the freedom engendered by Cubism and the interest in space on the part of the Constructivists but also through the availability of a new technique, welding. It was the Spaniard Julio Gonzalez who began to use welding and introduced it to Picasso. Since welding depends on heat,

(Right, top)
34. Robert Rauschenberg (American, b. 1925)
Ace, 1962
Oil on canvas with wood, metal, and cardboard
(combine painting), 108" x 140"
Albright-Knox Art Gallery, Buffalo, N. Y.
Gift of Seymour H. Knox.

(Right, bottom)
35. Corrado di Marca-Relli (American, b. 1913)
The Surge, 1958
Oil on canvas collage (assemblage), 54" x 71"
Contemporary Collection of the Cleveland Museum of Art,
Cleveland, Ohio.

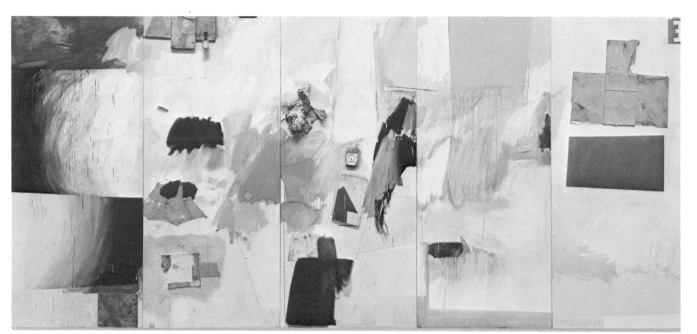

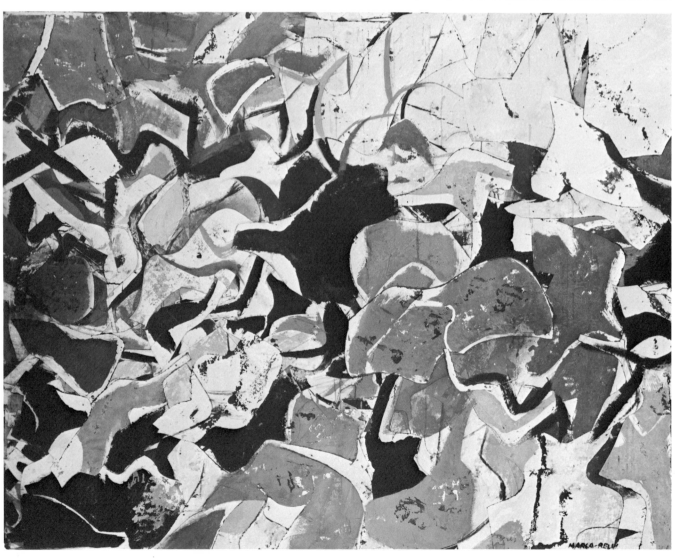

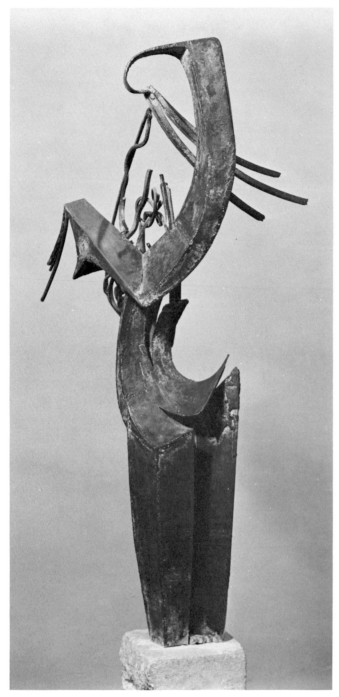

36. Julio Gonzalez (Spanish, 1876–1942)
Woman Combing Her Hair, 1936
Wrought iron, 52" x 23½" x 24⅝"
Collection, The Museum of Modern Art, New York, N.Y.
Mrs. Simon Guggenheim Fund.

more possibilities became apparent. With heat, metal pieces can be hammered into shapes and then welded together in such a way that the spaces between the parts become positive elements. By soldering and heating, the surfaces can be changed in texture and color.

Gonzalez found bronze and iron quite workable and not necessarily just hard and smooth. With heat he could create at will. These materials became as plastic as soft clay in his hands. Through his free working in iron and bronze he has inspired many others who can claim to be his heirs. His *Woman Combing Her Hair* (Figure 36) is certainly both inventive and humorous. It seems to follow the attitude of the Cubists and others of the earlier twentieth-century years: that the essence of a thing was more interesting and important than the familiar outer aspect. Here the rhythm of the parts and their balance suggest the activity and become more effective than a descriptive means would have been.

Pablo Picasso's *Baboon and Young* (Figure 37) is a key piece. It consists of found metal objects welded together. In their new association, these items lose their former identity but gain new meaning and importance by becoming a sculptural design. The collages of the early days of Cubism, when scrap paper and other materials took on aesthetic importance and therefore new meaning, foreshadow this. For example, the baboon's face and much of her head is made out of a toy metal automobile. The headlights are now facial features—the eyes—and thus their original meaning changes.

This new attitude toward sculpture can be found in the work of many American artists. David Smith, Richard Stankiewicz, John Chamberlain, Lee Bonticou, Ibram Lassaw, and Seymour Lipton have all found creative pos-

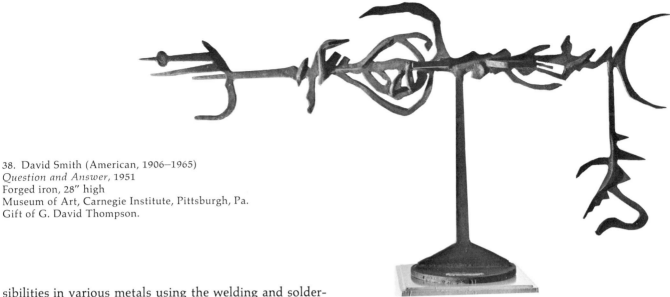

38. David Smith (American, 1906–1965)
Question and Answer, 1951
Forged iron, 28" high
Museum of Art, Carnegie Institute, Pittsburgh, Pa.
Gift of G. David Thompson.

sibilities in various metals using the welding and solder-
ing techniques. On the other hand, Louise Nevelson is
among those sculptors who find wood a suitable material.
The wood sculptures of Raoul Hague and Gabriel Kohn
represent an attitude different from Nevelson's.

David Smith knew the work of both Julio Gonzalez
and Pablo Picasso. He also had learned welding for in-
dustrial purposes. He started out as a painter, and, even
after he made sculpture his concern, he considered his
sculpture closely related to painting. This shows par-
ticularly in his attention to the surfaces of the shapes
for which color and texture are important.

The sort of image Smith developed suggests influence
not only from Cubism and the nonobjective styles of the
early part of the century, but also from the imaginative
and whimsical qualities found in Surrealism. Many of
his designs consist of linear elements, curving, angular,
and straight, often combined with geometric shapes
(Figure 38). These are free and open in organization al-
most like drawings in space. *Hudson River Landscape*,
1951 (see sixth page, bottom left, color section), makes
much reference to painting. It is two-dimensional, con-
fined within a limited area, and made up of pictorial
symbols, and in fact does derive from drawings. David
Smith made numerous sketches on his trips between
Albany and Poughkeepsie. There is a drawing which he
had signed as "River Landscape DS 1951 / Hudson
River from NYC tracks spring snow partially melted."[12]
The images have translated the scenery observed, even
though they exist as an abstract linear design.

12. Fry, David: *David Smith*. New York City: Solomon R. Gug-
genheim Museum, p. 79.

37. Pablo Picasso (b. Spain 1881)
Baboon and Young, 1951
Bronze, 21" high, base 13½" x 6⅞"
Collection, The Museum of Modern Art, New York, N.Y.
Mrs. Simon Guggenheim Fund

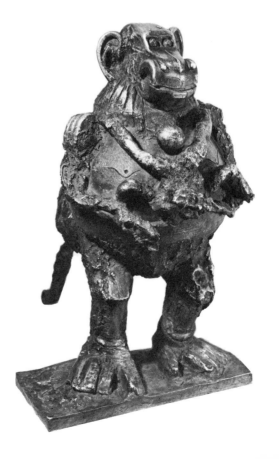

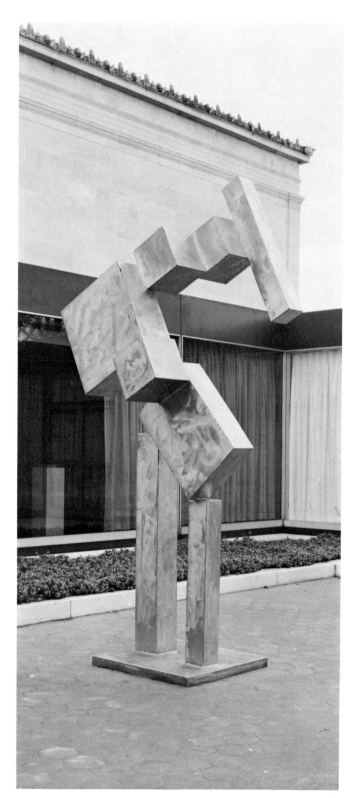

As time went on, Smith developed simpler combinations, concentrating on limited shapes like the *Cubi* series (Figure 39). These variations on the rectangle are organized in a very free manner. These *Cubi* compositions offer an arrangement that defies gravity and can only succeed physically because the pieces are firmly welded together. Visually they seem to be in balance, but only precariously poised before slipping apart. The surfaces have been buffed so that a random, swirling, linear effect results, dulling some areas, brightening others, and creating shimmer and movement. These *Cubi* pieces, and related ones (Figure 40), are best seen out-of-doors where light and shadow make them a vital part of their surroundings.

Another welder, Richard Stankiewicz, creates fantasies out of junk metal. His work is a real descendant of Picasso's *Baboon and Young* (Figure 37). A sculpture like *Kabuki Dancer*, 1956 (see sixth page, bottom right, color section), affronts many viewers with its rusting bits and pieces of once useful metal objects. Actually the rust colors are quite subtle, even beautiful, and the shapes very interesting. The pieces have been welded to make an open design which invites the viewer to see it from all sides. Once one gets over the shock of the junk and considers the sculpture from an aesthetic standpoint, it has much to offer. The artist forces the viewer to take stock. What is valuable? That which is new and costly but without lasting material value? Or that which is of aesthetic importance and lasting, namely color, shape, texture, and the resulting combinations?

(Left)
39. David Smith (American, 1906–1965)
Cubi XVI, 1963
Stainless steel, 11′ x 5′ x 33″
Albright-Knox Art Gallery, Buffalo, N.Y.
Gift of the Seymour H. Knox Foundation, Inc.

(Right)
40. David Smith (American, 1906–1965)
Untitled, 1964, April 10
Stainless steel, 117⅝″ x 69″ x 16¾″
Collection of the Newark Museum, Newark, N.J.
Gift of Mr. and Mrs. Charles W. Engelhard, 1967.

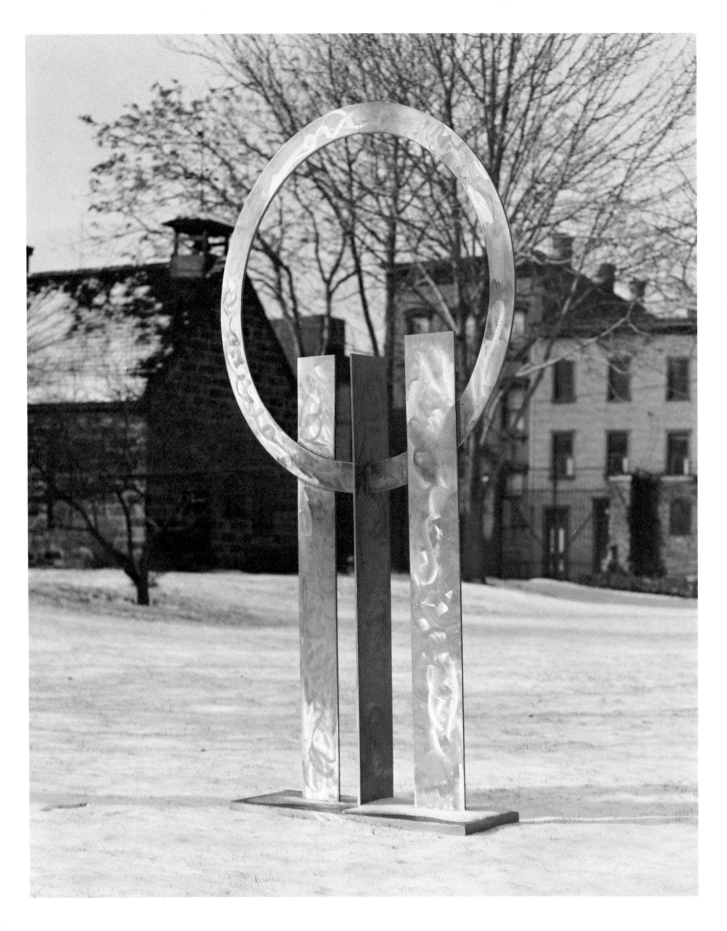

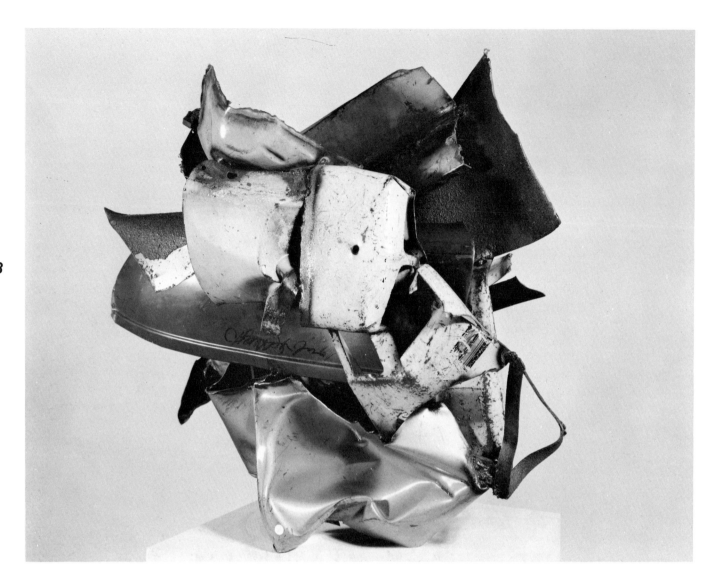

The sculpture of John Chamberlain provokes one equally. He too uses formerly useful old metal. He appears to raid automobile junkyards for pieces of car bodies (Figure 41). Then he cuts them into smaller pieces and reassembles them into sculptural form. The color of the original car remains even though it may have rust patches. The texture is that of the surfaces of the old metal unchanged. The jagged shape is an interesting one and truly sculptural in spite of its origin. Once again the sculptor challenges the viewer's values.

One woman artist also attended to the creation of welded sculpture. Lee Bontecou, who has been living in New York, makes intricate welded steel frameworks, cage-like, projecting out from a flat background (Figure 42). Between the slender pieces of this frame are pieces of old, dirty, and worn heavy canvas fastened in place by copper wire. The materials give the color and texture. The color of the canvas, however, is enhanced by passing the flame of a blowtorch over it to darken it more. Many openings appear in the relief-like shapes and these are dark and mysterious. The whole creation, in fact, is dark and mysterious and has a presence of its own.

(Left)
41. John Chamberlain (American, b. 1927)
Kroll, 1961
Steel, 25¾" x 28" x 20"
Albright-Knox Art Gallery, Buffalo, N. Y.
Gift of Seymour H. Knox.

42. Lee Bontecou (American, b. 1931)
Untitled, 1960
Metal and canvas, 43½" x 51⅝" x 12"
Albright-Knox Art Gallery, Buffalo, N.Y.
Gift of Seymour H. Knox.

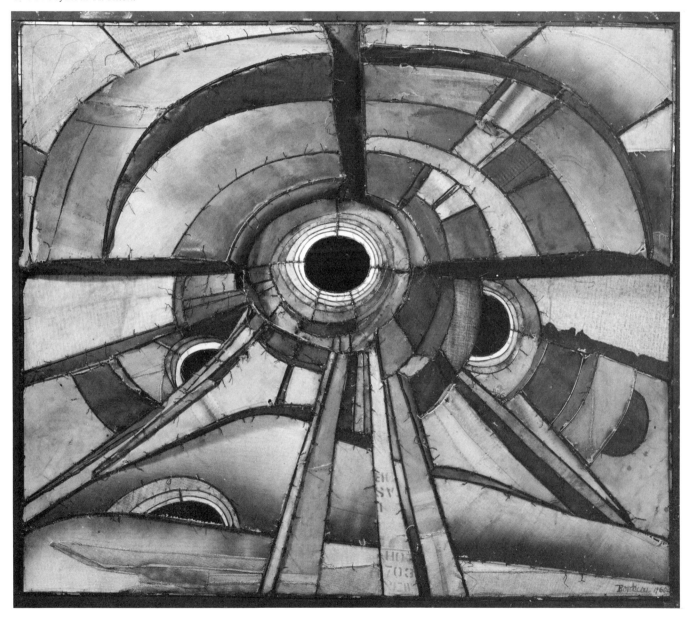

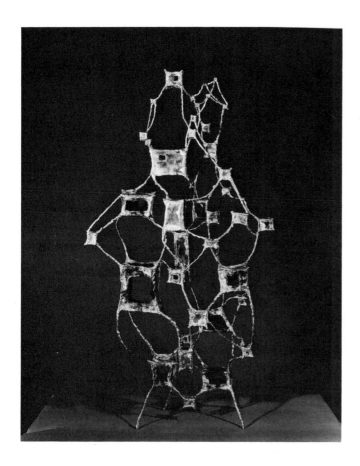

50

Another worker in metals is Ibram Lassaw. Some of his creations are veritable drawings in space, and *Theme and Variations* (Figure 43) is such a composition with wires soldered together, curved and bent, to form an open free web. Here and there in the web's spaces he has placed boxes of thin sheetcopper with one or two sides ripped open. The heat of soldering and the flux used give a rich color to the surfaces of these compartments. Lassaw has also used chemicals to enhance the color. Gilt bronze solder was melted over the wires of the web for color. The metal is his subject and with it he creates a delicate and attractive image.

Seymour Lipton has turned to a new metal developed earlier in the twentieth century, monel metal. Made for industrial use, Lipton found it suitable for his purposes although the forms he created from it derive from nature. He studies and collects things like shells and pine cones and these become springboards for inventive and ambiguous compositions. After he cuts the metal pieces, he shapes them by heat and hammering and welds them together so that the space flows through as well as around them. The surfaces glitter with the gilt-bronze bumpy solder melted over them. Lipton's sculpture, *Diadem* (Figure 44), has all these qualities as well as another quality often found in his work of this period, the combination of curving and angular elements. The total effect suggests the glitter and richness of a diadem.

For a number of years, Louise Nevelson has been using scrap wood to make complex relief-like sculpture. She combines mill ends, driftwood, pieces of cast-off furniture, boxes and barrels, and even old wooden manufacturing forms, into intricate arrangements in shallow boxes and piles them up to make mural-size reliefs (Figure 45). She then paints them black, or gold, or white,

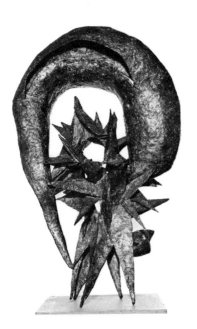

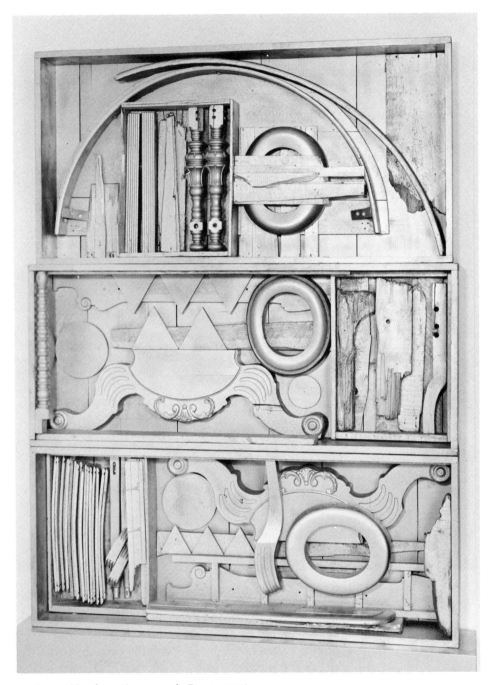

45. Louise Nevelson (American, b. Russia 1900)
Royal Game I, 1961
Wood with gold paint, 69" x 50½", top section;
69" x 51½", two lower sections
Albright-Knox Art Gallery, Buffalo, N.Y.
Gift of Seymour H. Knox.

46. Raoul Hague (American, b. Turkey 1905)
Mount Marion Walnut, 1952–1954
Walnut, 32½" x 36¾" x 26"; with base 36" high
Albright-Knox Art Gallery, Buffalo, N.Y.
Gift of Seymour H. Knox.

and this finish lends an elegance which unifies the assemblage, making the shape and surface variation more subtle. In recent years she has been making similar and elegant structures with Plexiglas. The light shines through the medium and the sparkle adds effect to the composition of spaces and recesses.

Raoul Hague uses a traditional material and method for his sculpture. Although he carves wood, he does not do so to imitate familiar things. Like the others, he makes the material his subject (Figure 46). His carving and polishing transform the log enough to bring out inherent

shape, color, and texture. The Hague sculpture contrasts in an interesting way with the wooden sculpture of *St. Gorgon* (Figure 5). The earlier artist used wood as a means to an end. He could have easily carved it out of stone or formed it from clay and painted the surface of these materials as he did the gesso-surfaced wood. For him wood was not the subject; instead, he transformed the wood into something else. There lies the difference between the two sculptors of widely different eras and attitudes.

Another approach to wood is found in Gabriel Kohn's work which resembles carpentry or shipbuilding techniques (Figure 47). Using planks of wood put together in layers, he creates large massive shapes often geometric in nature. These balance against one another in size and shape. The result is a composition which is rugged and vital.

While Marisol uses wood as the main material for *The Family* (Figure 48), the material is never completely transformed. Part of the humor of her portraits comes from the box and block forms and rather crude carving in addition to the drawing, painting of features, and addition of various materials and objects which enhance the statement. Her figures exist in an almost dream-like way in a never-never land. Even so, they have a strong appeal for the viewer in their humor and satire, and they relate very much to real people. Children find them to be like big funny dolls. Adults find them to be droll spoofs of all sorts of people, even themselves.

The contemporary sculptor exploits new materials and techniques. The new sculptures challenge us with their expressions of new values. It is interesting to consider in what directions sculpture will go in years to come. It is tempting to say that there will be something different.

53

(Above)
47. Gabriel Kohn (American, b. 1910)
Pitcairn, 1958
Wood, 23½" x 53½" x 24½"
Albright-Knox Art Gallery, Buffalo, N.Y.
Gift of Seymour H. Knox.

(Right)
48. Marisol (Marisol Escobar) (American, b. France 1930)
The Family, 1962
Painted wood and other materials, in three sections, 82⅝" x 65½"
Collection, The Museum of Modern Art, New York, N.Y.
Advisory Committee Fund.

Pop Art

The attitude dubbed Pop Art appeared in the work of a number of artists living in New York during the early sixties. These artists turned their attention to their immediate environment and focused on, or singled out, small segments or items of the most ordinary, mundane, and popular sort. In fact, for the Pop artist no separation between art and life exists. Their expression merely extended life. It is a very impersonal kind of art, quite unlike the subjective outpouring of Abstract Expressionism with its colorful and rather vague all-over statement. Pop artists intentionally worked in opposition to Abstract Expressionism. Pop Art is definite, clear, and precise. In some instances, it even makes use of an almost mechanical, mass-produced technique, making the result not only more impersonal but also more contemporary, even suggesting relationships to the more commercial aspects of our culture.

A movement called Pop Art had emerged in London a few years before it appeared in New York. It grew from a group of young artists and intellectuals who were fascinated by the mundane aspects of culture and taste which they found in such sources as American comic books. The American group really developed independently, and while the existence of the two at about the same time would seem to be coincidental, the shared designation was inevitable.

Actually the examination by artists of things in the immediate environment is not new. Artists have done this repeatedly over the centuries. For example, Jean Baptiste Chardin (1699–1779) painted still-life compositions in oil paint on canvas of items mostly from his own home, the kitchen, in fact (Figure 49)—a copper cooking pot, a vegetable, a cup, perhaps a glass or a candle. These homey items could hardly be more ordinary, but Chardin found an importance in their color, texture, and shape, and in the way they might blend or contrast. They also have a historical value in that these items were part of the painter's everyday surroundings, and the viewer sees them in a new manner.

William Michael Harnett (1848–1892) followed the tradition of Chardin in combination with a bit of *trompe l'oeil* (literally, "fool the eye"). *Still Life with the Toledo Blade* (Figure 50) is composed of things from Harnett's home, his everyday surroundings. While organized with attention to color and care in the placement of objects and interest in the variety of textures and sizes, the painting also creates the illusion of the actual objects rather than a representation of them.

In the middle of the nineteenth century, William Sidney Mount focused his attention on simple daily activities and events. There is nothing very heroic about eel spearing, but it was a part of life where he lived on Long Island.

Early in the twentieth century, Robert Henri, described as a Veritist, was an influential force. The way he looked at a subject and then painted it as he perceived it was echoed by his contemporaries and followers who formed the Ashcan School (Figure 51). During his sojourn in Paris, he was inspired by the period of Edouard Manet's work that harked back to the realism of Velasquez with its dark colors and free brush work. This, in turn, stimulated his own realism. He returned to Philadelphia and his studio became a center for the young avant garde who eventually moved to New York. John Sloan, along with George Luks, Everett Shinn, and William Glackens were among this group, and their work in New York earned them the dubious designation of "Ashcan School," from the backyards and life on the roof tops and along the city streets of New York that John Sloan made his subject (Figure 52). These subjects were surprising in their time since they were so ordinary, but they did mirror the lives of a majority of city dwellers.

In the contemporary environment, we are surrounded by many things, not always of the finest design, which express our culture, dominated as it is by advertising, mass-production, and material values.

Today the unreal world of the comic strips and movies and the out-of-reach world advertised in home magazines seem to embody our criteria for living. Is it any surprise then that some artists find these to be valid subjects when they figure so largely in today's surroundings?

The Pop artist selects from this mundane smorgasbord what interests him as typical. While the subject is selected with no pretense of preaching a moral, the choice results in sharpening the viewer's awareness of today's surroundings. The work results in making a comment on our environment and way of life today—and we may discover that we don't like it. This comment is a biproduct of the work since it stems from the aim of the artist.

The work of Schwitters forecast certain interests of the Pop artists. Some of his "mertz" compositions incorporated portions of comic strips along with other scraps from his immediate environment (Figure 32). His arrangements call attention to their aesthetic importance,

49. Jean Baptiste Simeon Chardin
(French, 1699–1779)
The Silver Goblet, ca. 1760–1761
Oil on canvas, 16⅞" x 19"
City Art Museum of St. Louis,
St. Louis, Missouri.

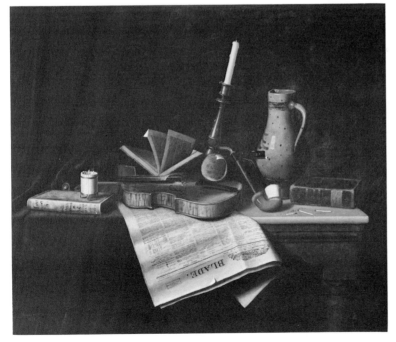

50. William Michael Harnett
(American, b. Ireland 1848–1892)
Still Life with the Toledo Blade, 1886
Oil on canvas, 22" x 26½"
The Toledo Museum of Art, Toledo, Ohio.
Gift of Mr. and Mrs. Roy Rike, 1962.

56

if nothing else. Rauschenberg has composed in a similar way, and his large combines (Figure 34) give a new significance to the cast-off items he gathered and used. Jasper Johns created images from items in everyday life, like the paintings featuring numbers (see sixth page, color section) and his famous American flags. There are his bronze reproductions of beer cans and flashlights. One is made to give such ordinary items another look, and they do become thought-provoking, although for some people they are sheer affront and seem to stop all thought-process and vision.

Andy Warhol is a name as ubiquitous as the Campbell's soup cans he paints. These soup cans are as much a part of our way of life as Chardin's copper cooking pots were part of his: we are certainly more apt to buy a can of soup than to make soup from "scratch." The soup can represents only one of the myriad of manufactured items on which we and our economy depend. Warhol's *100 Cans* (Figure 53) is even made in a technique that is suitable: oil paint put on the canvas with a stencil. An effective way to paint numerous identical items, stenciling also implies mass production, thereby emphasizing the impersonal aspect of life today. It is also an instance of the idea outweighing the means by which it is expressed. The artist can let someone else stencil it for him. The idea is the important thing, then, and for some artists craftsmanship and production have no part in their statement.

Roy Lichtenstein's art has gone through many phases but, over-all, his subjects are taken from popular culture. He is best known for his comic-strip paintings which in their almost heroic size emphasize the vapidness and fantasy which characterize many comic strips. These paintings call attention to the harsh colors of comics and to the hackneyed style typical of them and of much advertising art as well. In *Head, Red and Yellow* (see seventh page, top, color section), the girl's features are rendered by a scheme. The heavy line narrows and widens both to define shape and to suggest shadow. Bold

(Above)
54. James Rosenquist (American, b. 1933)
Nomad, 1963
Oil on canvas, with plastic paint, wood, and metal attachment, 84" x 210"
Albright-Knox Art Gallery, Buffalo, N.Y.
Gift of Seymour H. Knox.

(Right)
55. Tom Wesselmann (American, b. 1931)
Still Life #20, 1962
Wall relief assemblage: paint, paper, wood, light bulb, switch, sink fragment, and assorted objects, 48" x 48" x 5½"
Albright-Knox Art Gallery, Buffalo, N.Y.
Gift of Seymour H. Knox.

areas of white represent highlights. The skin areas of face and neck are "freckled" with the Ben Day dots, referring to the newspaper printing process. The very expression and facial type of the girl involve clichés.

Another Pop artist, James Rosenquist, worked for a time in commercial art. He was a sign painter, as some of his compositions suggest. The sleekness of surface and quality of color suggest an airbrush effect. *Nomad* (Figure 54) seems to be a montage of various signs or ads from billboards, TV, magazines, newspapers, whatever. Much of our "landscape" today consists of such images and we do not see the real countryside, what is left of it, for the forest of ads.

The work of Tom Wesselmann combines a variety of techniques to present an intimate view of everyday surroundings. He used illusionistically painted portions side by side with glued-on cutouts and actual objects. *Still Life No. 20* (Figure 55) is rather like a Chardin painting. Both are composed of things found at home which typify daily life in their respective periods. Both make use of contemporary techniques—Chardin using traditional oil for an illusion of reality, Wesselmann, the modern assemblage method. While Chardin created the illusion of the objects, Wesselmann used the actual objects in combination with commercial reproductions (ads) and some painted portions. There is the illusion of space and real space itself. In fact, in the simple primary colors, the rectangular divisions, and organization of the composition, it seems to echo the very spirit of the Mondrian reproduction which it includes. It produces another sort of illusion of reality, even, than the Harnett *trompe l'oeil* painting (Figure 50).

56. Allan D'Arcangelo (American, b. 1930)
Constellation #18A, 1970
Acrylic on canvas, 60" x 60"
Collection of the New Jersey State Museum, Trenton, N.J.
Museum purchase, 1970.

(Right, top)
57. George Segal (American, b. 1924)
The Butcher Shop, 1965
Plaster and miscellaneous objects, 94" x 99½" x 48"
Collection: Art Gallery of Ontario, Toronto, Canada.
Gift from the Women's Committee Fund, 1966.

Allan D'Arcangelo has been giving considerable attention to the highways which band the countryside and are intended to minimize the time/distance we travel. Some of his paintings show the center line disappearing off in the distance; others concentrate on highway furniture, such as warning signs and symbols (Figure 56). Limited to the road itself as these are they are very expressive of the restricted view of the driver as he concentrates on the job at hand. How many people spend much of their time on highways? It is a way of life for countless numbers, and D'Arcangelo paints their view of it. He also finds in it endless possibilities for design of color, form, and line.

Both George Segal and Claes Oldenburg concern themselves with the same sort of subject, and their work is chiefly sculptural. They deal with scenes and objects from everyday life. Both are equally inventive, but each has developed his own method and each uses quite different materials to create quite different images.

Like many of his fellow artists, Segal began as a painter and then became involved with sculptural expression. He began to use plaster to form the people whom he shows in ordinary everyday activity. In fact, this is the sort of activity many artists have represented.

Segal dips surgical gauze in plaster and wraps it around the person posing. Because plaster dries fast, the job has to be done quickly and in sections, each section being cut off the model as it is completed. Thus he forms a shell of gauze and plaster over the person but can do only small portions of it in succession. These portions are then assembled into a hollow cast of the person, and its ghostly whitness has a startling reality. The figure is often put in juxtaposition with props. People riding in a bus are on real bus seats. A man fixing a movie marquee works on a real marquee. A butcher in a butcher shop (Figure 57) has real tools—butcherblock, saw, and cleaver.

Segal's pieces are startling slices of life, and they haunt in their lack of exuberance and in their quiet seriousness. Such is *Cinema* (Figure 58), where the plaster figure of a man changes the letters of a theater sign. The sign and workman are both life-size and have their own space. The viewer, seeing them in a gallery, immediately relates to them as though on the scaffold with the workman. The result is almost a dream-like fantasy—real and not real.

61

(Below)
58. George Segal (American, b. 1924)
Cinema, 1963
Plaster statue, metal sign with illuminated plexiglass,
118" x 96" x 39"
Albright-Knox Art Gallery, Buffalo, N.Y.
Gift of Seymour H. Knox.

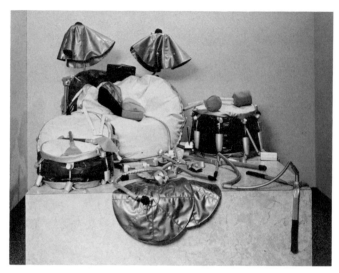

59. Claes Oldenburg (American, b. Sweden 1929)
Giant Soft Drum Set, 1967
Canvas, vinyl, wood, and mixed media, 84" x 72" x 48"
(125 pieces)
Collection of Kimiko and John Powers, Aspen, Col.
Currently on view at the Cleveland Museum of Art,
Cleveland, Ohio.

On the other hand, Claes Oldenburg's work is humorous regardless of its intent. Oldenburg began by making a store with all of its items for sale reproduced out of plaster. His art truly became an extension of life. Then there are the plaster reproductions of pies, cakes, ice-cream, and so forth. Somehow these always appear more real than the original—the cakes and pies seem cloyingly sweet. His next step was to cut and stitch cloth to create giant things like hamburgers (see seventh page, bottom, color section). Yet these, too, are right out of life and reflect the giant-size images in advertising. These cloth pieces are usually painted to resemble the real thing, but in a rather free and even expressive manner. Typewriters, sinks, and musical instruments such as drums (Figure 59) have appeared as soft and very unfunctional ghosts of themselves. The lack of paint makes them very insubstantial and even humorous.

The environment of the artist still provides endless subject matter and material for expressing it. As this section demonstrates, today's artist continues to explore it and to be excited by what he finds. The wide variety of material used is typical of the environment and of this period of time.

Motion / Light

The artist meets many challenges, some of them age-old, in expressing ideas. One challenge is how to express the idea of motion and movement from place to place. How many representations there are of people and animals moving about in all sorts of activity. An inanimate object like a tree blown by the wind is a problem for representation. Any one who has attempted such a thing in painting or sculpture has encountered the difficulties. The early attempts were stylized. The best known of these examples are the Egyptian paintings. The artist settled upon an arrangement to suggest movement, but the result is motion frozen because movement never occurs. The Renaissance period contributed with increased knowledge of anatomy and the new science of perspective. Even so, a painted, carved, or cast figure never really moves. It was not until the twentieth century that movement became an element for the artist to use.

The problem of light in painting went through a similar evolution. There was the Egyptian sun symbol, the disc with rays, which represented not only the God Ra, but his life-giving sunlight. Many centuries later, artists began to paint in the highlights and shadows indicating the presence of a source of light. Eventually light as a source of color became important. Finally in the twentieth century, light itself became still another element for the artist to use.

As we have seen, the early years of the twentieth century were noted for many innovations and interesting developments in the visual arts. Certainly light and motion are significant elements which, treated in new ways, have changed the character of painting and sculpture and added new dimensions to both. The work of certain European artists is pertinent to developments among American artists.

Marcel Duchamp, who was aware of the Futurists' concern with dynamic motion, began to investigate this problem. In 1911 he painted the *Nude Descending the Staircase* (Figure 60). The painting shows a succession of positions of the human body as it moves down a staircase. Duchamp's statement is very abstract because he did not define the parts of the body but rather concentrated on the shifting surfaces of the body in motion. This concentration is related to the presence and absence of light on these surfaces. The result is a sense of movement itself, rather than representation of the nude figure walking downstairs. The very abstractness of the painting alongside such a descriptive title created a problem for the viewer who expected a nude and found only geometric areas with no apparent human derivation. The painting appeared in the 1913 Armory Show in New York and immediately became the source of much puzzlement, amazement, amusement, and even frustration on the part of the general public who missed the point and refused to take the painting seriously.

As a member of the Futurists, Giacomo Balla made early studies concerning the representation of movement and transition. Muybridge and his studies of motion through photography were influential. A camera shutter was opened and objects moving past were recorded. The result was both pertinent and helpful, even though the passing object was a blurred image.

In 1912 Balla painted *Dog on Leash* (Figure 61), one of many paintings dealing with this problem of movement. Balla's painting suggests the moving object, but not as a blur. He gave the little dog many legs, tails, and other parts, to show the many positions of the parts of the body while running. As the viewer moves his eye over the succession of feet, etc., he experiences movement more effectively than he would if a frozen pose were used. All aspects of Balla's painting, not only the dog, but the person walking along with it, are handled by means of this multiplication of parts with each part in appropriate positions. Anyone looking at this painting senses the idea immediately.

Both artists were prophets of things to come. These new developments of the twentieth century reached out in many directions. The result is that both painting and sculpture require new definitions since they no longer conform to traditional ones.

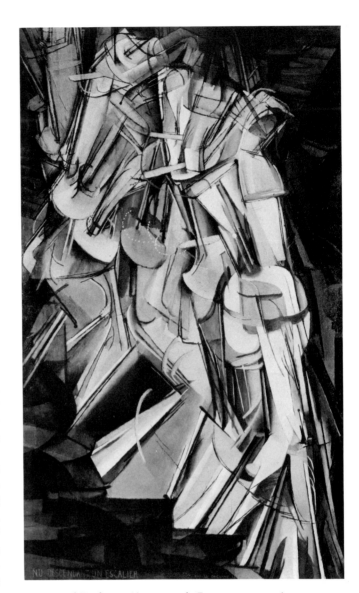

63

60. Marcel Duchamp (American, b. France 1887–1968)
Nude Descending a Staircase No. 2, 1912
58" x 35"
Philadelphia Museum of Art, Philadelphia, Pa.
Louise and Walter Arensberg Collection, '50-134-59.

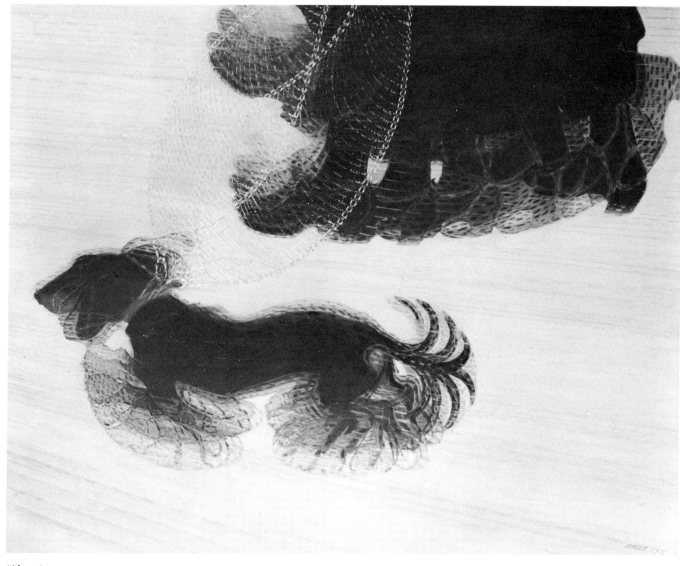

(Above)
61. Giacomo Balla (Italian, 1871–1958)
Dog on Leash, 1912
Oil on canvas, 35⅜" x 43¼"
Courtesy George F. Goodyear and the Buffalo Fine Arts Academy.
On view at the Albright-Knox Art Gallery, Buffalo, N.Y.

(Right, top)
62. Lazlo Moholy-Nagy (American, b. Hungary 1895–1946)
Light Space Modulator, 1930
Steel, plastics, and wood, 59½" high; base 27½" x 27½"
Courtesy of the Busch-Reisinger Museum,
Harvard University, Cambridge, Mass.
Gift of Sibyl Moholy-Nagy.

(Right, bottom)
63. Alberto Giacometti (Swiss, b. 1901)
City Square, 1949
Bronze, *ca.* 7" high; base 24½" x 15"
Courtesy Wadsworth Athenaeum, Hartford, Conn.

Lazlo Moholy-Nagy was a Bauhaus artist interested in three-dimensional form and light, shadow, and movement. His sculpture was a far cry from that of Michelangelo, although both were concerned with the same problems. Michelangelo based his ideas on the human form, however. Moholy-Nagy was interested in three dimensional light, shadow, and movement for their own sake and not in relation to nature. His *Light Modulator,* finished in 1930, reveals this interest (Figure 62). Machined, open-work, flat metal pieces are combined into a three-dimensional design and motorized, with lights included. As the sculpture moves, the lights flash within it and from it, and the effect is one of changing and even dissolving form. Such a piece relates to the space around it by seemingly blending into it.

Alberto Giacometti, the Swiss sculptor, has become well-known in the United States through exhibitions and the addition of his work to important public collections. For many years he has been making exhaustive and detailed studies of the human figure in order to comprehend it as thoroughly as possible. His sculptures might seem to belie that assertion since they are so simply stated. In the small bronze, *City Square,* 1949 (Figure 63), abbreviated figures, stick-like in character, stride fourth in a positive manner. Facing in different directions and staring straight ahead, four persons suggest the busy traffic of a city square. A fifth stands still and, while it is a sort of anchor, it also serves to emphasize the activity of the others. In its way, this sculpture is as expressive of movement as the Balla or the Duchamp paintings.

Alexander Calder, who comes from a family of sculptors, became the first American artist to concern himself with motion as an element in sculpture. Calder's sculptures began with wire "drawings" of which his *Circus* is a famous group. Made in 1926, *Circus* is his first wire sculpture as well as the first of his moving creations. Compositions operated by cranks and motors followed. By the 1930s he was deep into the problem of motion as an element of sculpture.

His first mobile was made in 1932 and depended upon wind. Countless hanging, standing, and wall mobiles followed from this prototype, some for indoors, some for outdoors. Calder's important meeting with Mondrian in 1930 encouraged this development of abstract sculpture and directed him toward use of the primary colors with black and white.

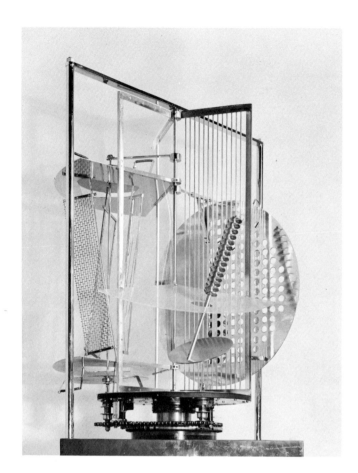

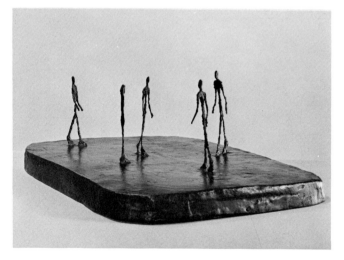

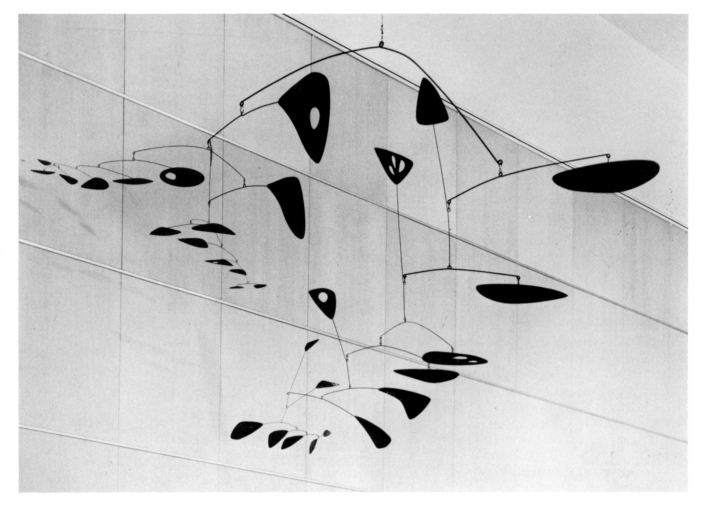

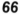

The mobile depends on a delicate balance of the parts which, for Calder, should be expressive of a unified idea. They were not mere gimicky gadgets of stuff hanging together to make something "cute" and of dubious artistic validity. Calder's mobiles (Figure 64) are carefully created: he used the right gauge of wire and rods, metal shapes, and more frequently, pieces cut from sheet metal of suitable gauge. The length of wire and the size, as well as the shape of sheet metal pieces, are important to the resulting composition. The parts are attached and looped together so that they may change their combination as air currents cause them to. But they are always in balance and always in new, if subtle, rhythm enhanced by the primary colors usually in combination with black and white. In recent years Calder has combined mobiles with stabiles. These latter are abstract, free, but static forms in sheet metal which are sculpture in their own right.

George Rickey has created beautifully handcrafted sculptures of two or more parts which sway with air currents (Figure 65). He makes slender three-sided shapes tapering to a point which are weighted at one end so that they remain at balance in a certain arrangement. When the air currents activate them, they sway back and forth in opposite directions as far as the weights permit. The delicacy of the moving stainless steel parts enhances the graceful rhythm. All of his compositions are carefully worked out before he puts them together. However, the air currents that set the parts going limit the actual movement possible.

Len Lye, a New Zealander who has been in the United States since 1946, has for many years been interested in movement which eventually came to be expressed in sculpture. He makes his motorized and programmed sculptural designs out of flexible steel strips or pieces of wire. The movement of the sculpture creates a sense of shape. Sometimes the pieces accelerate, and the snap of the metal produces sharp sounds. Naum Gabo earlier in the century had created such an effect with a rotating flexible rod which, as it spun, created a "shape."

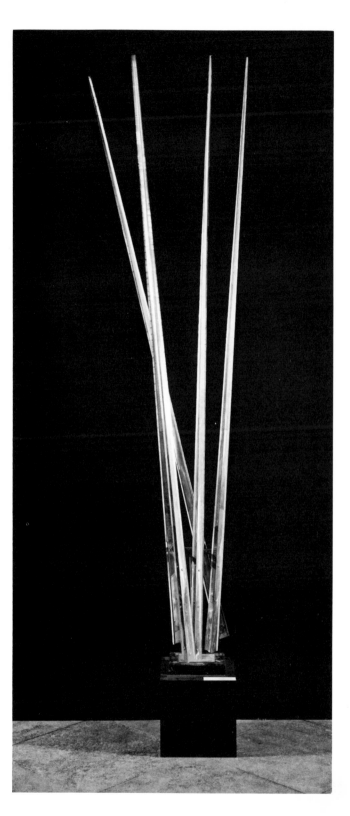

(Left)
64. Alexander Calder (American, b. 1898)
Black Spread, 1951
Steel mobile, 6' x 12'
Des Moines Art Center, Edmundson Art Foundation, Inc.
Des Moines, Iowa. James D. Edmundson Collection.

(Right)
65. George Rickey (American, b. 1907)
Peristyle: Five Lines, 1963–1964
100" x 10" x 13"
Albright-Knox Art Gallery, Buffalo, N.Y.
A. Conger Goodyear Fund.

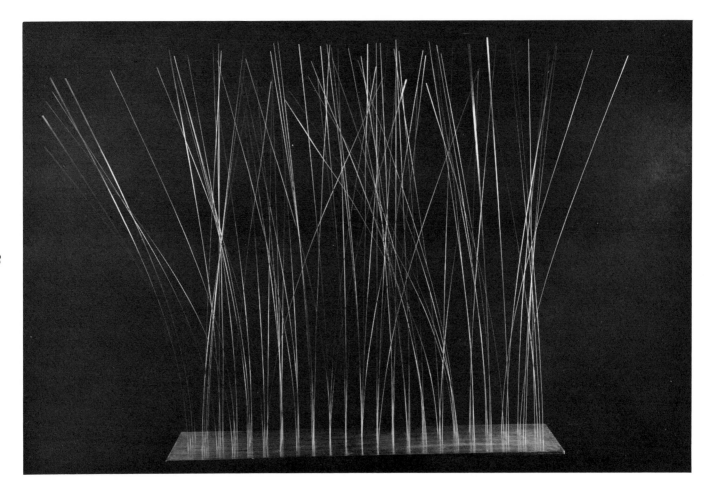

Grass (Figure 66), by Len Lye, consists of long, fine, very flexible wires inserted into a wooden base which is attached to a motor programmed to tilt it back and forth and cause the wires to sway. The piece is well-named because it evokes the idea of tall grass blowing gently in the sunlight.

The incorporation of light as an actual element in a work of art has been noted earlier in connection with the comments about Moholy-Nagy (Figure 62). By the 1960s it had become the concern of many artists.

In 1962 Tom Wesselmann incorporated a fluorescent bulb into his *Still life No. 20* (Figure 55). Since the work deals with various degrees of illusion from implied to real, the light, with its switch which the viewer may turn off and on, makes an effect which conventional representation would not have achieved.

George Segal has made use of illumination in *Cinema*, of 1963 (Figure 58). The movie sign which forms the background for the plaster figure of a workman is lit from behind by lights. Such backlighting lends credibility to the group and also gives the figure an added mystery by silhouetting it.

Howard Jones is one of the American artists who has made light the primary element in his work. *Bronze Star*, 1967 (Figure 67), consists of an elegant box of spun bronze in which are inserted many small lights whose radial arrangement forms concentric circles. The lights have a complex programmed sequence and at no time are

all of them on at once. They flash on and off making bright patterns whose reflections gleam from the surrounding spun bronze surface. Watching them produces a hypnotic effect akin to that of watching the dancing flames in a fireplace.

Victor Millonzi's *Standing Blue* (Figure 68) is formed of slim neon filled tubing, part white and part blue. It flashes on and off in a regular manner, transforming the space around it.

Millonzi's work is in step with what several other American artists have been doing, among them Billy Apple and Chryssa. Both Chryssa and Apple have formed light sculpture using glass tubing filled with gas, often neon. The tubes are bent to their specifications and, together with colored and white lights, they make a design which dominates its surroundings and often makes reference to environmental effects. While Chryssa has made a series of light alphabet letters, she has become known for her large *Times Square* piece and this certainly refers to the environment—what place in the country is better known for its neon lights and signs than Times Square in New York?

Dan Flavin uses regularly manufactured fluorescent lights, mounting them so that they define space or else emphasize existing space.[13] His interest is less in colored light than in the way light and lighted surfaces relate to and modify space.

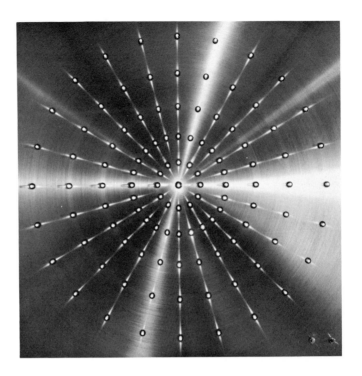

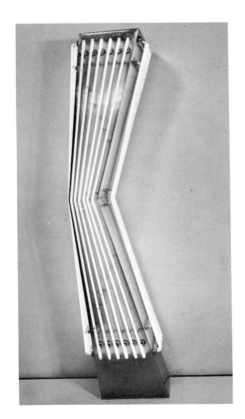

(Left)
66. Len Lye (American, b. New Zealand 1901)
Grass, 1965
Stainless steel wire in wood, motorized, 3' high including base and wire, base 35⅝" x 8"
Albright-Knox Art Gallery, Buffalo, N.Y.
Gift of Howard Wise Gallery.

(Above)
67. Howard Jones (American, b. 1922)
Bronze Star, 1967
Spun bronze with programmed lights, 36" x 36" x 2"
Albright-Knox Art Gallery, Buffalo, N.Y.
Gift of Seymour H. Knox.

(Right)
68. Victor Millonzi (American, b. 1915)
Standing Blue, 1966
Neon and stainless steel, 67" x 16" x 13½"
Albright-Knox Art Gallery, Buffalo, N.Y. Anonymous gift.

13. Wilson, William S.: "Dan Flavin: Fiat Lux." In *Art News*, Vol. 68, No. 9, January 1970, pp. 48–51.

Optical Illusion / Op Art

Op Art, as it is practiced in recent years, refers to paintings whose surfaces seem to be in continual flux. This effect may be created by black and white design or by colors. An Op painting generally has hard edges and precise areas and lines. There is no focal point to which the elements refer; instead, their organization is all-over. Needless to say, a true Op painting is abstract, with no reference to the real world by any degree of representation. The purpose is to engage the eye of the viewer so that a sensation of movement of the picture plane (surface) results.

Some of the examples already discussed in other connections need to be reconsidered briefly. They deal with optical problems—how the eye sees and reacts—but they are not pure "Op."

While optical illusions and effects in painting have been made by artists throughout the history of art, pure optical effects have appeared only in contemporary times. For example, the Impressionists developed their technique of divided color so that the eye would perceive the mixture of the colors which actually existed side by side. This was done, however, to express as fully as possible the transitory moment the artist was observing, whether out-of-doors or indoors. The Impressionist took an interest in light and its relation to form, space, and color, and he developed his technique to that end. Claude Monet's *Woman Seated Under the Willows* (see first page, color section), shows this very well. Impressionist painting never lost sight of the place or the objects, nor did the later Pointillists, like Georges Seurat. Actually these Post-Impressionists wanted to create a solidity of form, which they found lacking in Impressionism, with their juxtaposition of dots of color.

Then there is the optical illusion of movement observed in the paintings by Marcel Duchamp (Figure 60) and Giacomo Balla (Figure 61). Emphasizing the shift of surfaces of a human form in motion, Duchamp created the idea of movement very effectively. Balla, by means of multiplying the anatomical parts of the dog, its leash, and the feet of its companion, treats the eye of the viewer to the experience of dog and person hurrying along.

Morgan Russell, that American who came under the influence of Cubism during his Parisian sojourn, has already been discussed (Figure 13). In his abstract painting, he developed on the surface of the canvas a sensation of the shift of colors both two-dimensionally and even forward and backward in depth. He achieved this nonobjective effect purely through the arrangement of geometric areas of color.

Among the European nonobjective painters, Mondrian offers something in this respect (see fourth page, color section). The brighter colors appear to advance, and the duller appear to recede as they relate to the black bars which organized them on the surface of the canvas. However, the surface does not appear to be in full motion, as it does in later Op paintings.

Perhaps Victor Vasarely is the earliest optical painter. He began with just black and white geometrically derived patterns which thoroughly transformed the surface into motion. More recently he has worked with intricate and subtle color combinations and variations for the same effect. His *Vega-Nor* (Figure 69) bulges out and bulges in, but this activity is only in the eye of the beholder. It is achieved by changes in size and direction of the bands of color in combination with subtle changes in the color values. Since the effect depends on exactness, a very thin mixture of oil paint has been used for a better intensity of color which requires, for best effect, a smooth untextured surface and sharp edges.

Bridget Riley, a young British woman who has been occupied with pure Op painting for a number of years, creates a composition which really seems to undulate and shift ceaselessly. The eye of the viewer can be engaged so that a physical experience akin to dizziness occurs. *Drift No. 2* (Figure 70), in its subtle array of grey-greens, appears to ripple endlessly .

European artists like Vasarely and Riley have exercised a great influence on recent American artists through exhibitions and the inclusion of their work in collections, to say nothing of the many reproductions of their work in publications. An even more direct influence has been exerted by Josef Albers. He taught at Black Mountain College, where Rauschenberg was one of his students, and then at Yale, from 1955 until his retirement, where another of his students was Richard Anuszkiewicz. He was the first teacher to come directly from the Bauhaus, making this experience and background definite factors in the direction that American art would take. Through Léger's visit and later teaching, Mondrian's few years in New York before his death, and Hans Hofmann's school in New York, the nonobjective style of painting gained a real foothold among the younger American artists. This, coupled with European Op Art developments, had a far-reaching effect.

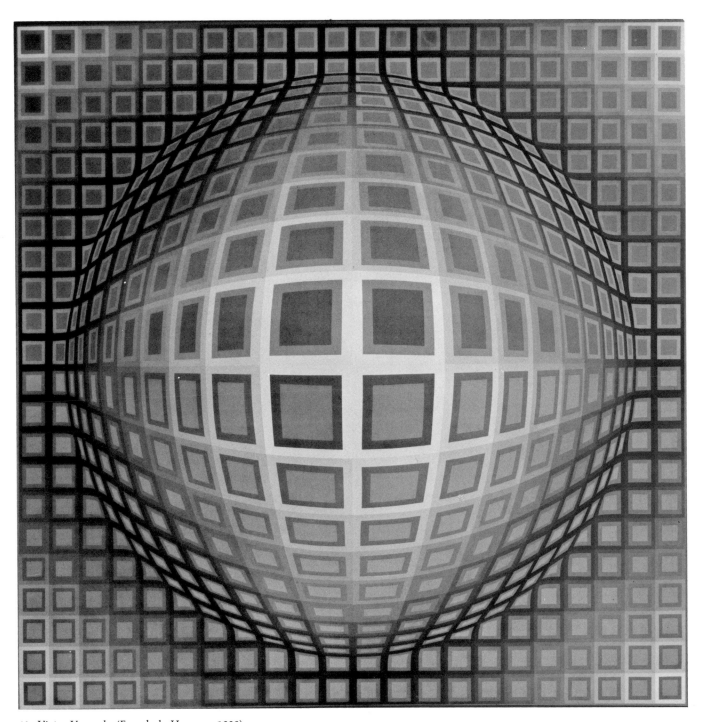

69. Victor Vasarely (French, b. Hungary 1908)
Vega-Nor, 1969
Oil on canvas, 78¾″ x 78¾″
Albright-Knox Art Gallery, Buffalo, N.Y.
Gift of Seymour H. Knox.

72

(Left)
70. Bridget Riley (British, b. 1931)
Drift No. 2, 1966
Acrylic on canvas, 91½" x 89½"
Albright-Knox Art Gallery, Buffalo, N.Y.
Gift of Seymour H. Knox.

(Above)
71. Joseph Albers (American, b. Germany 1888)
Homage to the Square: Dedicated, 1955
Oil on masonite, 43" x 43"
Albright-Knox Art Gallery, Buffalo, N.Y.
Gift of the Seymour H. Knox Foundation, Inc.

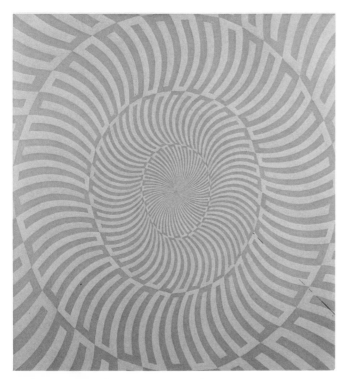

72. Richard Anuszkiewicz (American, b. 1930)
Water from the Rock, 1961–1963
Oil on canvas, 56" x 52"
Albright-Knox Art Gallery, Buffalo, N.Y.
Gift of Seymour H. Knox.

While Josef Albers' work is not strictly Op, although closely related, it opened the way for younger artists to investigate. For about twenty years, his interest has been concentrated on organizing his abstract geometric designs with the square as their basis.[14] His *Homage to the Square* (Figure 71) series has infinite variety of color, frequently limited to ranges of one hue. These paintings are squares within squares, but while having a centered vertical axis, the top to bottom margins are not equal. This lends a free and even floating effect and perhaps thereby enhances the interaction of the various colors or values of a color. Albers' color compositions create afterimages which result when one color area causes the eye to see the area as an "echo." Albers combines colors so that they can temper each other to greater, and sometimes lesser, intensity. The planes of color forming the painting appear to be suspended in space.

Richard Anuszkiewicz had been a prize-winning realist painter for a number of years.[15] However, his experience at Yale with Albers led him to concentrate, during the past twelve or so years, on pure color organized geometrically in bands and areas which create an optical sensation. In one of his earlier paintings, *Water from the Rock* (Figure 72), curving and tapering bands of oil colors radiate from the center, seeming to undulate over and move away from the canvas surface. It conveys a feeling of vertigo. The three colors—pale blue, light green, and light orange—alternate, creating in their juxtaposition secondary colors apparent only in the eye of the viewer. This sort of color relationship has continued to intrigue Anuszkiewicz. *Iridescence* (Figure 73) is such a composition, consisting of three colors only: vermillion, blue, and green. Yet their combination, and the width and relative positions of the strips, would lead the viewer to believe that perhaps as many as seven colors were used rather than only three. Except for its complete non-objective aspect and geometric character, such painting can be compared to that of both Impressionist and Post-Impressionists because the juxtaposition of colors makes other colors seem to exist.

Russian born Alexander Lieberman has been an American citizen since 1946.[16] He is a painter, filmmaker, director at Conde Nast publications, and a sculptor. For a number of years, his painting has been nonobjective and geometrically based. *Iota III,* 1961 (Figure 74), is reminiscent of optical tests often made in schools. The black ring and the white disc over which it is centered are both placed against a bright vermillion ground to create an optical illusion: the ring appears to have a greater diameter than the disc. Actually both have identical dimensions.

Frank Stella is a young American artist who, like the others under consideration, is on the fringes of Op Art.[17] His compositions for the most part have been restricted to the painting of parallel bands of color on square or rectangular surfaces. At first he used only black aluminum paint, then one or two colors (Figure 75). The shapes have since been modified by the rectangles being

14. *See* Shapiro, David: "Homage to Albers." In *Art News*, Vol. 70, No. 7, November 1971, pp. 30–33, 96–97.

15. Johnson, C. B.: "Optical Illusion." In *Gallery Notes*, Buffalo: Buffalo Fine Arts Academy, Albright-Knox Art Gallery, XXVII, No. 2, Spring 1964, pp. 3–6.

16. Campbell, Lawrence: "The Great Circle Route." In *Art News*, Vol. 69, No. 2, April 1970, pp. 52–57, 61–62.

17. Baker, Elizabeth C.: "Frank Stella: Perspective." In *Art News*, Vol. 69, No. 3, May 1970, pp. 46–49, 62–64.

73. Richard Anuszkiewicz (American, b. 1930)
Iridescence, 1965
Acrylic on canvas, 60" x 60"
Albright-Knox Art Gallery, Buffalo, N.Y.
Gift of Seymour H. Knox.

76

(Left)
74. Alexander Lieberman
(American, b. Russia 1912)
Iota III, 1961
Oil on canvas, 80" x 45"
Albright-Knox Art Gallery, Buffalo, N.Y.
Gift of The Seymour H. Knox Foundation, Inc.

(Right)
75. Frank Stella (American, b. 1936)
Fez, 1964
Fluorescent alkyd on canvas, 77" x 77"
Albright-Knox Art Gallery, Buffalo, N.Y.
Gift of Seymour H. Knox.

cut into to make v-shapes, parallelograms, and even combinations of these. The rectangle is no longer the only shape for the field of a painting. From parallels and angles, Stella has developed intricately entwined curving patterns in bright pure acrylic colors. The purity of unmixed color in his recent work shows him to be a direct descendant, in terms of pure color interest, of the Fauves, such as Derain.

Larry Poons began as a musician before taking up painting while studying at the Boston Museum of Fine Arts School, 1957–1958. Like the others, his prime concern is color. *Orange Crush*, 1963 (see last page, top, color section), exemplifies what he has been doing. Consisting of two complementary colors, pale green dots against an orange field, the painting treats the viewer to an optical experience. The green dots appear to become detached and to dance over the surface and are soon seen as pale, pale orange "echoes" of themselves. The eye reacts to the strong contrast of color and the scattering of the small dots over a large area. The dots are not put in at random but are placed on a grid carefully drawn in pencil on the canvas. While later paintings are freer in the character of the dots and use less color contrast, the principle appears to remain constant. Recently Poons has built up caked surfaces which crack in the drying, creating texture which affects the color.

Peter Young, born in 1940, currently lives in Utah [18]. His work had already evolved through several stages before his latest dot paintings. Thick dots of paint, often in limited color range, cover the surface of the canvas and seemingly have no beginning, no end, and no limits (see last page, bottom, color section). Actually, as the eye follows them and adjusts to their astigmatic effect, a subtle pattern emerges. The surface moves gently, and the result is an Op painting.

Ron Davis is a West Coast artist living in Los Angeles. He has turned to very contemporary materials, acrylic or polyester resin paint with fiberglass. The colors are applied to the back of a fiberglass surface only a fraction of an inch thick. Support and paint dry together, and the result is a unit unlike the usual painting with pigment and medium applied to a prepared surface.

Plane Sawtooth, 1970 (Figure 76), gives an amazing illusion of three-dimensional shape. It is not a rectangle, but the irregular form it appears to be. It resembles a set of three steps seen from an angle, and even close up its real two-dimensionality does not seem convincing. The juxtaposition of transparent areas and seemingly shadowed portions with seemingly light-struck surfaces contributes to the experience of seeing an actual three-dimensional object. In its way it is as convincing as the geometrically constructed Italian Renaissance perspective. The architectural setting in *The Annunciation* (Figure 3) by Romano, is a case in point.

Concern with transforming the surface of a painting has definitely taken new directions through the work of the Op Artists. A new reality of motion results from the selection of color and the organization of it. A new excitement and challenge is provided for the viewer when his eye encounters such a composition. He can become physically involved to the degree sometimes of sensing motion in his body.

18. Wood, James N.: *Six Painters*. Buffalo: Buffalo Fine Arts Academy, Albright-Knox Art Gallery, 1971.

76. Ron Davis (American, b. 1937)
Plane Sawtooth, 1970
Polyester resin and fibreglass, 60" x 140"
Albright-Knox Art Gallery, Buffalo, N.Y.
Gift of Seymour H. Knox.

What Next?

It would be unfortunate if this study left the impression that "this is it," with no room for further development into uncharted directions. Signs of such evolution are evident. The whole history of art rests upon change from experiments and discoveries. These new directions have formed the very basis of this study: each group, while an outgrowth of the past, has made its own statement with respect to the factors in its own environment.

Increasingly, artists are creating monumental sculpture which has to be manufactured in a foundry which provides both sufficient space to accommodate the size of the final piece and the necessary skilled labor. While construction frequently takes place under the direction of the artist, the job can be accomplished without him if he supplies a mock-up and sufficient detailed specifications. Tony Smith is among the sculptors whose abstract works are intended to be out-of-doors, to coexist with the space and buildings of the area. *Cigarette* (Figure 77), conceived in 1961, was executed in 1967 in Cor-ten steel by a metal-working shop near Buffalo where the piece was to be installed. Cor-ten steel undergoes a surface change with weathering which involves not disintegration but rather a change of color and texture that acts as a means of preservation. This material has become an important one for those contemporary sculptors who find its particular qualities suitable to their environmental interests.

New sculptural materials and greater scale are only partial indications of new directions. Another appears in the work of Kenneth Snelson (Figure 78). Using porcelainized aluminum tubing and fine but very strong steel wire, Snelson creates spacious open designs which really need the out-of-doors to breathe in. Interchangeable combinations are possible in some of the pieces so these sculptures need not remain in a static design. The balancing of the tensions within the piece itself is essential, and this is as much an engineering problem as it is a sculptural one. There is nothing of mass or volume in such a Snelson piece.

The work of these artists does not resemble traditional monumental sculpture made for public places in years past. Their sculptures are not figurative and have no message, historic, moral, or otherwise. Instead, they exist in their own right, and their organic quality is enhanced by the space they occupy and in which they belong. Perhaps a recent prototype for this sort of thing is Gabo's

(Right)
77. Tony Smith (American, b. 1912)
Cigarette, conceived 1961 and executed 1967
Cor-ten steel, 15' x 18' x 26'
Albright-Knox Art Gallery, Buffalo, N.Y.
Gift of the Seymour H. Knox Foundation, Inc.

80

(Above)
78. Kenneth Snelson (American, b. 1927)
Audrey I, 1965
Porcelainized aluminum and steel wire
Collection, John G. Powers, Aspen, Col.
Currently on view at the Cleveland Museum of Art,
Cleveland, Ohio. Photographed by the artist
at Aspen Meadows House #6.

(Right)
79. Jules Olitski (American, b. Russia 1922)
Second Tremor, 1969
Acrylic on canvas, 81" x 105"
Albright-Knox Art Gallery, Buffalo, N.Y.
Gift of Seymour H. Knox.

(Left)
80. Sam Gilliam (American, b. 1933)
Blue Extension, 1969
Acrylic on canvas, 10' x 50'
Collection, Jefferson Place Gallery, Washington, D.C.
(Installation view at Corcoran Gallery, Washington)

(Right)
81. Robert Breer (American, b. Bulgaria 1935)
Floats, 1968
Photograph by Frances Breer.

84

eight-foot abstract sculpture made in 1957 for the post–World-War-II Bijenkorf stores in Rotterdam, Holland.

Jules Olitski, in the last few years, has developed large scale paintings whose surfaces are covered by layer after layer of finely sprayed acrylic paint (Figure 79). There is, as a rule, only a hint of shape made by the deepening of color close to one or two edges of the painting. Otherwise, the painting is a shimmer of color and light not unlike the enlargement of an area of a Pointillist painting, but without the dots being enlarged and without reference to natural forms. Purely abstract, it gives the sensation of color for its own sake and is made more dynamic by huge scale. The 81" x 105" size of *Second Tremor* is modest in comparison to some of Olitski's other paintings which are much larger. Its atmospheric color also makes it a descendant of Impressionism.

Then there is Sam Gilliam who departs even further. The canvases he paints are made to be draped and are not stretched on a stretcher or hung against a wall in the usual fashion. The paint is sprayed and dripped on and otherwise applied in a manner which suggests the work of Pollock. However, each composition is planned to be draped with its folds in a certain arrangement, either against a wall or suspended from the ceiling. The result is almost sculptural and certainly is fully three-dimensional (Figure 80).

Programmed art has already been considered, but those examples were stationary, unable to move as a unit from place to place. Robert Breer has made sculptures out of Styrofoam slabs, paper bags, and other ordinary materials, and fitted them with a simple, battery-driven motor. These "floats" (Figure 81), as he calls them, move freely, if slowly and creepily, at random from place to place. Upon bumping into an obstruction they merely go off in another direction. They definitely have a life of their own, dominant wherever they may be.

Laser beams are being used to create designs in space. Rockne Krebs has been grappling with this possibility for exhibitions both indoors and out-of-doors.[19] The weaving of pulsating colored beams bouncing off mirrors in a darkened room is eerily beautiful.

The work of Christo is certainly unique and seems to be anticreative and even anti-art. He specializes in wrapping up objects, making mysterious packages out of them.[20] One of his large packaging jobs was the

19. *Rockne Krebs: Day and Night Passage*, an exhibition at the Albright-Knox Art Gallery, Buffalo, New York, February 14–April 30, 1971.
20. Prokopoff, Stephen S.: *Christo: Monuments and Projects*. Philadelphia, Pa.: Institute of Contemporary Art, University of Pennsylvania. Exhibition October 5–November 11, 1968.

wrapping of the Chicago Museum of Contemporary Art in 1969. It was wrapped for forty days in 10,000 square feet of canvas tarpaulins. Why does he do this? An easy reply would be "for a stunt" or "for the fun of it." Actually, Christo wraps things up to emphasize their mystery since we know so little about them to begin with. Such a procedure makes the object, or the building, a sculptural mass, in any case.

Christo also drew up a plan to wrap the Museum of Modern Art in New York (Figure 82). The preparatory study indicated his rather formal training in Bulgaria where he developed skill in drawing. The study is an assemblage, combining drawing, photography, and pieces of cloth to indicate the project. In addition to this preparatory study, he made several other drawings as well as three-dimensional models and photomontages. Wrapping something, even something as large as the Museum of Modern Art, is important to Christo because he thereby transforms it, making it obscure, and even destroying any function it might have.[21] Its outer aspect becomes sculptural while its inner aspect has not necessarily changed.

More recently, Christo has made the headlines due to his attempt with the Valley Curtain Project For Colorado, 1970–1972.[22] It was a Herculean and painful effort involving many frustrating months, involving the talents of skilled engineers and workmen and of course gigantic expense. The limited success was short-lived and never fully achieved according to original intent.

Nancy Graves is perhaps unusual among contemporary artists because she finds inspiration from the past, the far distant past, and primitive religions.[23] What she creates makes an archaeologist out of the viewer who seems to be discovering remnants of early culture on his own. Camels, live ones, became her first inspiration in this direction. Not only was she attracted by their odd shapes, but by the fact that they date back to prehistory, even in America. In forming the camel shape, she found herself comparable to early man who imagined or formed an idea, sensed its significance, and then created its image. The cavepainter very likely went through such a

(Right)
82. Christo (Javacheff Christo), (b. Bulgaria 1935) *Museum of Modern Art Packed Project*, 1968 Photomontage, oil, pencil, and pasted drawing on cardboard, 15⅝″ x 21¾″ Collection, The Museum of Modern Art, New York, N.Y. Gift of D. and J. de Menil.

21. Van Der Marck, Jan: "Why Pack a Museum?" In *Arts Canada* 26:34–37, October 1969.
22. *See:* p. 15 (#13) in catalog of Seventh American Exhibition: The Art Institute of Chicago; June 24–August 20, 1972.
23. Wasserman, Emily: "A Conversation with Nancy Graves." In *Artforum*, Vol. IX, No. 2, October 1970, pp. 42–47.

86

"THE MUSEUM OF MODERN ART PACKED" PROJECT

process. In forming the creature she is also aware of its outer and inner aspects and the fact that it participates in the birth-death-rebirth cycle. In addition to all this, she appreciates the camel shape for the sculptural problems it offers. More recently, she has been concerned with the bones of the camel and she has been recreating its fossils which she forms out of materials such as plaster, gauze, wax, marble dust, and acrylic. Scattered about the floor of her studio or of a gallery (Figure 83), these fossils force the viewer to see, to see them not as a whole but in small groups that are parts of a whole. In passing such static objects, the viewer also creates movement and even change.

There are many ideas at work in Nancy Graves's statements about camels, their bones, fossils, and skeletal forms. The viewer is given not only a new experience but also an opportunity to widen his vision and to bring present and past into some kind of relationship.

The work of the earth artists presents us with another unusual development. They dig trenches across deserts, sometimes relating or orienting one to the other even though they might be half a world apart. Michael Heizer's *Double Negative* (Figure 84) is a work which both relates to and transforms its environment. It slices into a mesa, normally flat tableland, and anyone walking in it would be made keenly aware of its gigantic size—it has displaced 240,000 tons of earth—and that it has not changed the scale of the mesa. It must change the look of the mesa, however, as the light plays over it and shadow is caught in the cut.

Why do artists like Heizer and the other "earth workers" express themselves in this way and call it art? They are being revolutionary for one thing, perhaps for the sake of being revolutionary. If so, perhaps, they are indicating that art as it has been traditionally known has run its course. Perhaps they are indicating that the cultural environment is such that this is the only kind of statement they can make. Certainly these artists are not content with usual modes of expression but seem challenged to make their own statement by changing the environment. Some of the Surrealists have already expressed the frustrations of man's attempts in this direction, the limp and unfunctional watches in Salvator Dali's *Persistence of Memory* being a case in point. The modern earth artist does not see art as something set apart for special viewing but as a natural part of everyday surroundings and experience—a deep cut in a mesa, a spiral pattern dug in a desert floor.

Lucas Samaras has been interested in environment and space. *Mirrored Room*, one of about three that he has made, is an environment. Since all surfaces are covered with mirrors, once one stands inside it (Figure 85), the usual sense of wall, floor, and ceiling as limits to space vanish, and one becomes suspended and fragmented in an endless sparkling environment. The outside (Figure 86) of this room blends with its surroundings because everything around it is in it by means of reflection. One's normal sense of reality and dimension experienced in the normal environment is destroyed. The *Mirrored Room* thrusts the visitor into a new environment which actually is as endless as the real one in which we live.

Standing on the threshold of the *Mirrored Room* is perhaps akin to standing and anticipating what the tomorrows ahead will bring for art. A world of possibilities reaches out endlessly in all directions.

(Right)
85. Interior view of Figure 86.

86. Lucas Samaras (American, b. Greece 1936)
Mirrored Room, 1966
Wooden framework covered by mirrors, 8' x 8' x 10'
Albright-Knox Art Gallery, Buffalo, N.Y.
Gift of Seymour H. Knox.

Kuh, Katharine: *Break-up: The Core of Modern Art.* Greenwich, Conn.: New York Graphic Society, 1965.

Male, Emile: *Religious Art.* New York: Pantheon Books, Inc., 1949.

Penrose, Roland: *The Sculpture of Picasso.* New York: The Museum of Modern Art, 1967.

Rewald, John: *History of Impressionism.* New York: The Museum of Modern Art, 1961.
_____: *History of Post-Impressionism.* New York: The Museum of Modern Art, 1956.

Rose, Barbara: *American Art Since 1900.* New York: Frederick A. Praeger, Inc., 1967.

APPENDIX

Bibliography

Part One

Adams, Henry: *Mont-Saint Michel and Chartres.* Garden City, N.Y.: Doubleday and Co., Inc., Anchor Books, 1959.

Barr, Alfred H. Jr.: *Cubism and Abstract art.* New York: The Museum of Modern Art, 1936. Reprint, New York Arno Press, 1966.

Brown, Milton W.: *The Story of the Armory Show.* New York: The Joseph H. Hirshhorn Foundation, 1963.

Cooper, Douglas: *The Cubist epoch.* London: Phaidon Press in association with Los Angeles County Museum of Art and The Metropolitan Museum of Art, 1971.

Fry, Edward F.: *Cubism.* New York: McGraw-Hill Book Co., 1964–1966.

Gardner, Helen: *Art through the Ages.* New York: Harcourt Brace and Co.

Gray, Christopher: *Cubist Aesthetic Theories.* Baltimore: The Johns Hopkins Press, 1953 (1967).

Hartt, Frederick: *History of Italian Renaissance Art.* New York: Harry N. Abrams, Inc., 1969.

Jaffe, H. L. C.: *De Stijl.* Amsterdam, 1956.

Part Two

Arnason, H. H.: *Marca-Relli.* New York: Harry N. Abrams, 1963.

Barrett, Cyril: *Op Art.* London: Studio Vista, Ltd., 1970.

Calder, Alexander: *Calder: An Autobiography with Pictures.* New York: Pantheon Books, 1966.

Coplon, John: *Andy Warhol.* Greenwich, Conn.: New York Graphic Society, 1970.

Corcoran Gallery of Art: *George Rickey, Sixteen Years of Kinetic Sculpture,* Washington, D.C., 1966.

Elsen, Albert: *Seymour Lipton.* New York: Harry N. Abrams, 1970.

Forge, Andrew: *Rauschenberg.* New York: Harry N. Abrams, 1969.

Fry, Edward F.: *David Smith.* New York: Solomon R. Guggenheim Foundation, 1969.

Gallery of Modern Art: *Franz Kline Memorial Exhibition.* Washington, D.C., 1962.

Giedion-Welcker, Carola: *Contemporary Sculpture: An Evolution in Volume and Space.* New York: Wittenborn, 1960.

Hess, Thomas B.: *Willem de Kooning.* New York: Museum of Modern Art (New York Graphic Society, 1969) 1968.

Hunter, Sam (ed.): *Art since 1945*. New York: Harry N. Abrams, Inc., 1958.

Kozoloff, Max: *Jasper Johns*. New York: Harry N. Abrams, 1968.

Kuh, Katharine: *The Artist's Voice: Talks with Seventeen Artists*. New York: Harper & Row, 1962.

Kulterman, Udo: *The New Sculpture, Environments and Assemblages*. New York: Frederick A. Praeger, Inc., 1968.

Lippard, Lucy: *Pop Art*. New York: Frederick A. Praeger, Inc., 1966.

O'Connor, Francis V.: *Jackson Pollock*. New York: The Museum of Art, 1967.

Pellegrini, Aldo: *New Tendencies in Art*. New York: Crown Publishers, Inc., 1966.

Perlman, Bennard P.: *The Immortal Eight: American Painting from Eakins to the Armory Show*. New York: Exposition Press, 1962.

Ponente, Nello: *Modern Painting: Contemporary Trends*. Cleveland: World Publishing Co., 1960.

Popper, Frank: *Origins and Development of Kinetic Art*. Greenwich, Conn.: New York Graphic Society, 1968.

Rickey, George: *Constructivism*. New York: George Braziller, Inc., 1967.

Ritchie, Andrew: *Sculpture of the Twentieth Century*. New York: The Museum of Modern Art, 1952.

Rose, Barbara: *Claes Oldenburg*. New York: The Museum of Modern Art (New York Graphic Society, Greenwich, Conn.), 1970.

Rubin, William Stanley: *Frank Stella*. New York: The Museum of Modern Art (New York Graphic Society, Greenwich, Conn.), 1970.

Russell, John, and Suzi, Gablik: *Pop Art Redefined*. London: Thames and Hudson, 1969.

Sandler, Irving: *The Triumph of American Painting: A History of Abstract Expressionism*. New York: Frederick A. Praeger, Inc., 1970.

Seitz, William Chapin: *The Art of Assemblage*. New York: The Museum of Modern Art, 1961.

_____ : *Hans Hofmann: With Selected Writings by the Artist*. New York: The Museum of Modern Art (Doubleday, Garden City, N.Y.), 1961.

_____ : *The Responsive Eye*. New York: The Museum of Modern Art, 1964.

Selz, Peter: *Mark Rothko*. New York: The Museum of Modern Art (Doubleday, Garden City, N.Y.), 1961.

Shulman, Leon: *Marisol*. Worcester, Mass.: Worcester Art Museum, 1971.

Sweeney, James J.: *Alexander Calder*. New York: Solomon R. Guggenheim Museum, 1964.

Taylor, Joshua: *Futurism*. New York: The Museum of Modern Art, 1961.

Tompkins, Calvin, and the Editors of Time-Life Books: *The World of Marcel Duchamp*. New York: Time, Inc., 1966.

For past and current developments, the following periodicals are important secondary sources:
The Art Gallery, Ivoryton, Conn. 06442.
Art in America, 150 E. 58 St., New York 10022.
Art International, Via Maraini, 17-A, Lugano, Switzerland.
Art News, 444 Madison Ave., New York 10022.
Artforum, 667 Madison Ave., New York 10021.

Collections of Twentieth-Century Art

Most of these museums and collections have 35mm slides, color reproductions, reproductions of sculpture and other items. Write for price lists of what is available.

Arizona
Tucson: University of Arizona Art Gallery

California
Berkeley: University of California, The University Art Gallery
Los Angeles: Los Angeles County Museum of Art
Pasadena: Pasadena Art Museum
San Francisco: M. H. De Young Memorial Museum Museum of Art
Santa Barbara: Santa Barbara Museum of Art

Colorado
Colorado Springs: Colorado Springs Fine Arts Center
and Taylor Museum
Denver: Denver Art Museum

Connecticut
Hartford: Wadsworth Athenaeum
New Haven: Yale University Art Gallery,
Société Anonyme Collection

District of Columbia
The Corcoran Gallery of Art
The Gallery of Modern Art
The Phillips Collection
The Smithsonian Institution, National Collection
of Fine Arts; Joseph Hirshhorn Collection

Illinois
Champaign: University of Illinois,
Krannert Art Museum
Chicago: The Art Institute of Chicago

Indiana
Muncie: Ball State Teachers' College, Art Gallery
Notre Dame: University of Notre Dame, Art Gallery
Terre Haute: The Sheldon Swope Art Gallery

Iowa
Des Moines: Des Moines Art Center

Louisiana
New Orleans: Isaac Delgado Museum of Art

Maine
Ogunquit: Museum of Art of Ogunquit

Maryland
Baltimore: The Baltimore Museum of Art

Massachusetts
Boston: Museum of Fine Arts
Cambridge: Harvard University, The Busch-Reisinger
Museum; The Fogg Art Museum
Lincoln: De Cordova and Dana Museum
Waltham: Brandeis University, The Rose Art Museum
Worcester: The Worcester Art Museum

Michigan
Ann Arbor: University of Michigan, Museum of Art
Bloomfield Hills: Galleries-Cranbrook Academy of Art
Detroit: The Detroit Institute of Art
Kalamazoo: The Kalamazoo Institute of Art

Minnesota
Minneapolis: Minneapolis Institute of Art
The Walker Art Center
St. Paul: St. Paul Art Center

Missouri
Kansas City: Nelson Gallery-Atkins Museum
St. Louis: The City Art Museum
Washington University, Art Museum

Nebraska
Lincoln: University of Nebraska Art Galleries,
Sheldon Memorial Art Gallery

New Jersey
Newark: The Newark Museum
Trenton: The New Jersey State Museum

New York
Brooklyn: The Brooklyn Museum
Buffalo: The Albright-Knox Art Gallery
Elmira: Arnot Art Gallery
Ithaca: Cornell University, Andrew Dickson White
Museum of Art

Manhattan: The Metropolitan Museum of Art
The Museum of Modern Art
The Solomon R. Guggenheim Museum
The Whitney Museum of Art
Rochester: Rochester Memorial Art Gallery
University of Rochester
Schenectady: The Hyde Collection
Syracuse: The Everson Museum
Syracuse University, Lowe Art Center
(Art School)
Utica: The Munson-Williams-Proctor Institute

Ohio
Cincinnati: Cincinnati Museum of Art
Contemporary Art Center
Cleveland: The Cleveland Museum of Art
Columbus: The Columbus Gallery of Fine Art
Dayton: Dayton Art Institute
Oberlin: Oberlin College, Allen Memorial Art Museum
Toledo: The Toledo Museum of Art

Pennsylvania
Allentown: Art Museum
Philadelphia: The Philadelphia Museum of Art
Pittsburgh: Museum of Art, The Carnegie Institute

Rhode Island
 Providence: Rhode Island School of Design,
 Museum of Art

Texas
 Dallas: Museum of Fine Arts
 Houston: Contemporary Arts Association
 Museum of Fine Arts of Houston
 University of St. Thomas Collection
 San Antonio: Marion Koogler McNay Art Institute

Vermont
 Waitsfield: Bundy Art Gallery

Wisconsin:
 Milwaukee: Milwaukee Art Center, Inc.
 The Walker Art Center

Washington:
 Seattle: Seattle Museum

Canada: Ontario
 Toronto: The Art Gallery of Ontario

Sources for Fine Art Reproductions

Harry N. Abrams, Inc.
110 East 59th Street
New York, New York 10022

Artext Prints, Inc.
Westport, Connecticut 06880

Artistic Picture Publishing Co., Inc.
151 West 26th Street
New York, New York 10001

Haddad's Fine Arts
P.O. Box 5522
Buena Park, California 90620

International Art Publishing Company
243 West Congress Street
Detroit, Michigan 48226

New York Graphic Society, Ltd.
140 Greenwich Avenue
Greenwich, Connecticut 06830

Poster Originals
16 East 78th Street
New York, New York 10021

Shorewood Reproductions Inc.
724 5th Avenue
New York, New York 10019

University Prints, Inc.
15 Brattle Street
Cambridge, Massachusetts 02138

Three-Dimensional Reproductions

Alva Museum Replicas, Inc.
30-30 Northern Boulevard
Long Island, New York 11101

Museum Pieces, Inc.
15 West 27th Street
New York, New York 10001

The Sales Department
The University Museum
33rd and Spruce Streets
Philadelphia, Pennsylvania 19104

35mm Slides

American Color Slide Library, Inc.
305 East 45th Street
New York, New York 10017

Budek Films and Slides, Inc.
P.O. Box 307
Santa Barbara, California 93102

GAF Corp.
Box No. 444
Portland, Oregon 97207

McGraw-Hill Book Company
1221 Avenue of the Americas
New York, New York 10020

Prothmann Associates
650 Thomas Avenue
Baldwin, L.I., New York 11510

Sandak, Inc.
39 West 53rd Street
New York, New York 10019

Society for Visual Education, Inc.
1345 West Diversey Parkway
Chicago, Illinois 60648

Universal Color Slide Company
132 West 32nd Street
New York, New York 10001

University Prints, Inc.
15 Brattle Street
Cambridge, Massachusetts 02138

Sources for Films on Art and Artists

ACI Films, Inc.
 35 West 45th Street
 New York, New York 10036

Audio Film Center
 34 MacQueston Parkway South
 Mount Vernon, New York 10550
 406 Clement Street
 San Francisco, California 94118
 1618 North Cherokee
 Los Angeles, California 90028
 8615 Director's Row
 Dallas, Texas 75247
 512 Burlington Avenue
 La Grange, Illinois 60525

BFA Educational Media
 2211 Michigan Avenue
 Santa Monica, California 90404

CCM Films, Inc.
 866 Third Avenue
 New York, New York 10022

Contemporary Films/McGraw Hill
 1212 Avenue of the Americas
 New York, New York 10020

Film Images (division of Radim Films, Inc.)
 1034 Lake St.
 Oak Park, Illinois 60301
 220 West 42nd Street
 New York, New York 10036

Ideal Pictures
 102 West 25th Street
 Baltimore, Maryland 21218

42 Melrose Street
Boston, Massachusetts 02116
3910 Harlem Road
Buffalo, New York 14226
512 Burlington Avenue
LaGrange, Illinois 60525
8615 Directors Row
Dallas, Texas 75247
1120 Broadway
Denver, Colorado 80203
1370 S. Beretania Street
Honolulu, Hawaii 96814
15 E. Maryland
Indianapolis, Indiana 46204
1619 North Cherokee
Hollywood, California 90028
352 Union
Memphis, Tennessee 38103
55 N.E. 13th Street
Miami, Florida 33132
4431 West North Avenue
Milwaukee, Wisconsin 53208
3400 Nicollet Avenue
Minneapolis, Minnesota 55408
34 MacQueston Parkway South
Mount Vernon, New York 10550
234 S.E. 12th Avenue
Portland, Oregon 97214
200 East Cary Street
Richmond, Virginia 23219
406 Clement Street
San Francisco, California 94118

International Film Bureau, Inc.
 57 East Jackson Blvd.
 Chicago, Illinois 60504

Masters and Masterworks Productions, Inc.
 1901 Avenue of the Stars, Suite 700
 Los Angeles, California 90067

Museum of Modern Art Film Library
 11 West 53rd Street
 New York, New York 10019

Visual Resources, Inc.
 1841 Broadway
 New York, New York 10023